CENTRAL GLASGOW
THROUGH TIME
Etta Dunn

AMBERLEY

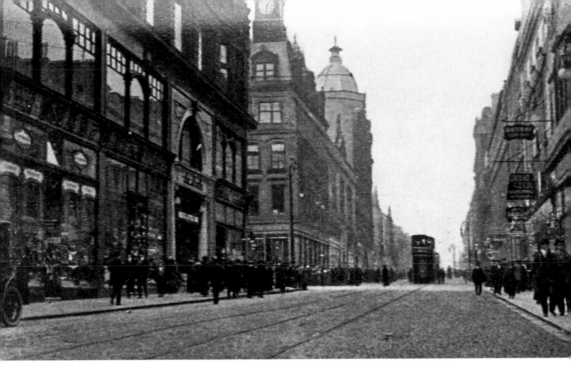

Sauchiehall Street

First published 2014

Amberley Publishing
The Hill, Stroud, Gloucestershire, GL5 4EP
www.amberley-books.com

Copyright © Etta Dunn, 2014

The right of Etta Dunn to be identified as the Author
of this work has been asserted in accordance with the
Copyrights, Designs and Patents Act 1988.

ISBN 978 1 4456 3870 6 (print)
ISBN 978 1 4456 3887 4 (ebook)

British Library Cataloguing in Publication Data.
A catalogue record for this book is available from the
British Library.

Typesetting by Amberley Publishing.
Printed in Great Britain.

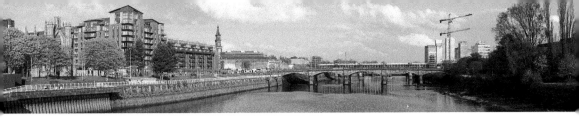

Introduction

'Tis the cleanest and beautifullest, and best built city
in Britain, London excepted.

Daniel Defoe, 1707

This book provides a somewhat potted history of the growth of Glasgow, told by way of illustration and brief text, from the first engraving of Glasgow Cathedral by John Slezer in 1693 to the present-day photographs taken in 2014. It is not a history book, but where possible I have provided information as a basis for further investigation, should the reader be so inclined.

The story of the origin of Glasgow starts in the mid-sixth century, with a young, unmarried, pregnant girl called Thenew (or Thenue), the daughter of King Lleuddun, Llew, or Loth, after whom Lothian was named. In his book about the life of St Mungo the monk, Jocelin of Furness states that Thenew's baby's father was Owain, son of Urien, King of Rheged, her father's brother. However, further research has indicated that Owain would perhaps not even have been born at the time, and that Urien is more likely to be the baby's father.

Some reports indicate that Thenew was so enamoured of her new Christian religion that she wanted to emulate the Virgin Mary and have a child out of wedlock. Of course, the word virgin at that time had no sexual connotation and meant only an unmarried girl. Some say that she was raped, some say that she had an affair. Bearing in mind that sex outside marriage was a capital offence under Scots Law at the time, it seems most likely that she had been raped. However, whether by fate or by design, her unmarried but pregnant status meant that her father was obliged to kill her. He arranged for her to be strapped to a cart and pushed off Traprain Law, a hill just outside Edinburgh. Miraculously, she survived. This made people label her as a witch. She was then cast adrift on the Firth of Forth in a coracle with no oars.

Legend has it that she was carried on 'shoals of fishes' to Culross, where she gave birth to Kentigern (meaning Chief Lord). They were taken into the monastery and cared for by St Serf, who reared Kentigern and educated him. St Serf nicknamed the boy Mun-gho, meaning dear or beloved one. This made Mungo's classmates jealous, and they tried to cause trouble for him. This led to the first two of Mungo's miracles: first, they killed Saint Serf's pet robin and blamed it on Mungo, who immediately prayed for the bird and brought it back to life; second, when Mungo was given the responsibility of keeping the holy fire alight, they extinguished it while he was asleep. On wakening, Mungo collected a few frozen hazel twigs for the fire, blew on them, prayed, and they burst into flames. Thus the holy fire was relit.

One harvest time at the monastery, the cook died and there was no one to cook the meals for the workers. Saint Serf instructed Mungo to 'either take the cook's place or bring him back to life'. Mungo brought the cook back to life.

Eventually, Mungo obeyed a 'calling' to leave Culross, as he believed that his duty lay elsewhere. He headed south where the waters of the Forth reputedly opened to allow him to pass. Then he travelled west to Kernach, near Stirling, where he found an old Christian holy man named Fergus who was dying but wouldn't go until someone came who would restore the district to the faith of St Ninian. Almost as soon as Mungo arrived, Fergus collapsed and died. Mungo placed the body on a cart pulled by two wild bulls and commanded them to take him to a place of rest decided by the Lord. The bulls stopped at the top of a hill in Cathures, the earliest known name for Glasgow, where Fergus was buried in ground consecrated for Christian burial by St Ninian in AD 397. It is thought that the Blacader Aisle of Glasgow Cathedral may mark the spot. Mungo thought that the place was beautiful, with its grey volcanic rock (now the Necropolis) and the sparkling water of a burn (the Molendinar) meandering down to the River Clyde. He called it Glasghu, meaning dear green place.

Mungo's reputation must have preceded him. Almost immediately he was visited by the king, and the leading men of the old area of Strathclyde (which stretched from Loch Lomond to Cumbria) entreating him to be their religious leader. He was soon consecrated by a bishop brought from Ireland for the occasion.

Thirteen years later, Mungo had to flee to Wales to escape the wrath of King Morken's family, who believed that, after a quarrel where Morken had been violent towards him, Mungo had, with his considerable miraculous powers, caused Morken to be thrown from his horse and killed.

In AD 573, after his victory at Arthuret near Stirling, Rydderch Hael was crowned King of Strathclyde. He immediately sent a message to Mungo urging him to return to Glasghu, which he did. St Mungo's deeds are remembered in the following verse:

> Here is the bird that never flew
> Here is the tree that never grew
> Here is the bell that never rang
> Here is the fish that never swam

The 'bird' refers to the robin that Mungo brought back to life. The 'tree' refers to the hazel twigs with which Mungo relit the fire. The 'bell' refers to the handbell, used by Mungo to call his flock to prayer. The 'fish' refers to the story that King Rydderch, after seeing a ring that he had given his wife, Queen Langoureth, on the finger of one of his knights, got him intoxicated, took the ring off the knight's finger and threw it into the Clyde. He then accused his wife of infidelity and demanded to see the ring. Fearing for her life, she begged Mungo to help her. He sent a monk to catch one fish from the Clyde. A salmon was subsequently brought to him and inside the salmon was the ring.

These four symbols are now incorporated into the design of some of the Glasgow lamp posts and they are used in the Glasgow Coat of Arms, with the motto, 'let Glasgow Flourish'. The words originally came from a St Mungo sermon, 'Lord let Glasgow flourish by the preaching of the word and the praising of thy name.'

Glasgow did indeed flourish, growing from a small hamlet to the second city of the Empire.

Glasgow Epithets

Glasgow the undernourished, the downtrodden, the under-rated, the over-populated,
the see me, the see you, the demolished and littered,
the brash, the slave wealthy, the soot blackened sandstoned,
the emphysemal, the bowly-legged, the cursed and glottal-stopped.

Glasgow the back-of-the-queue, the second-rater,
the has-been trader, the benefit raider, the slang slagged, the cosmopolitan voiced,
the green and blue divided, the apologetic, the bread-lined,
the sawdust – floored and the slum-ridden.

Glasgow the Clyde dependant, the shipbuilder, the tobacco merchant led,
steel-making, train-making, built on fifty seven hills,
home to refugees and asylum seekers fae a' airts and pairts.

Glasgow the de-flowered, the pregnant, the blooming,
the cultured, the thriving, the bon-vivant,
the burgeoning, where-it's-at place to be.

Etta Dunn

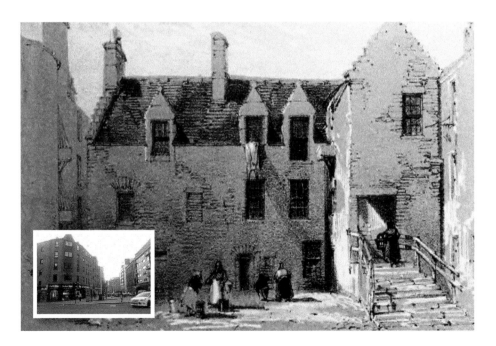

No. 157 High Street
No. 157 High Street is no longer there – numbers now jump from 155 to 159.

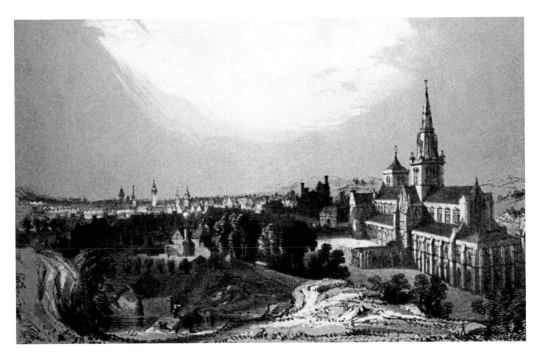

Glasgow Cathedral

Above: Looking west from Fir Park (now Glasgow Necropolis) with the cathedral and Bishop's Palace (Glasgow Castle) on the right, around 1690. *Below:* The cathedral and Necropolis from the south west. This postcard is postmarked 7 October 1904. The Necropolis was officially opened in 1833, but the Jewish section dates back to 1832. The John Knox memorial, seen below (the highest one at the brow of the hill), predates the Necropolis as it was erected in 1825. Saint Mungo's tomb lies in the lower crypt.

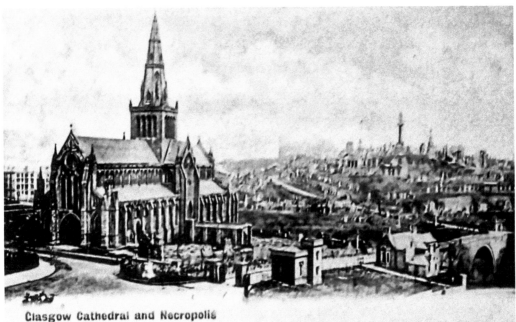

Glasgow Cathedral and Necropolis

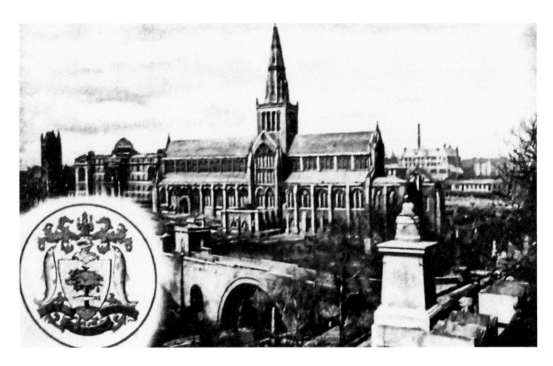

Bridge of Sighs, Pre-1907

The bridge over the Molendinar Burn was the route for funeral processions between the Royal Infirmary, seen to the left of the cathedral, and the Necropolis, hence the nickname (after the Bridge of Sighs in Venice). This Royal Infirmary building was demolished in 1907. Joseph Lister, now known as the father of modern antisepsic, initiated the use of carbolic acid for cleaning hands and instruments before and after surgery while he was Professor of Surgery here from 1860. The new building (*seen below*), designed by James Miller, took seven years to build, opened in 1914, and is now 100 years old.

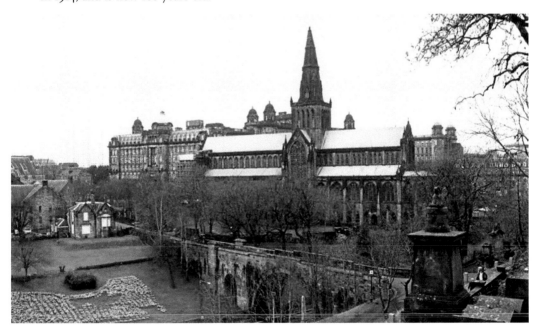

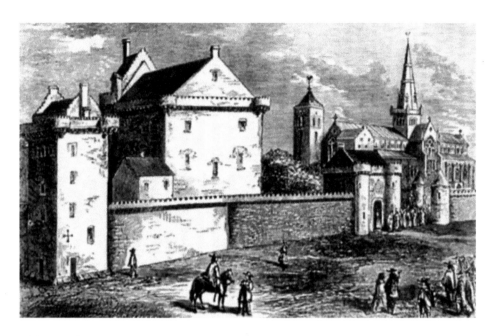

Bishop's Palace

King Edward I's troops were garrisoned here until beaten by William Wallace in the Battle of the Bell o' the Brae. This engraving shows the Bishop's Palace from the south-west, pre-Reformation in 1560, in relation to the cathedral. *Below:* Part of the Bishop's Palace and St Nicholas's chapel can be seen in disrepair around 1780.

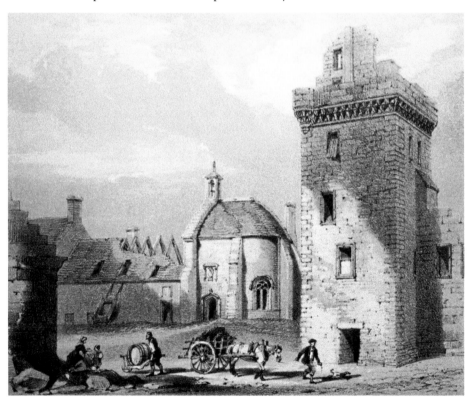

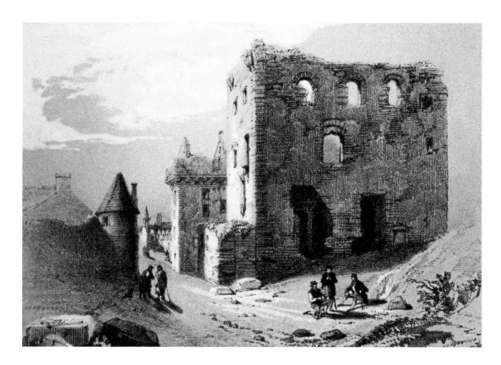

Bishop's Palace in Ruins

The ruined Bishop's Palace was eventually demolished in 1792 to make way for the first Royal Infirmary (*see top of page 7*), designed by Robert and James Adam. The new building, opened in 1814, can be seen below to the left of the St Mungo Museum of Religious Life and Art, which opened in 1993 and houses artefacts of all the major religions of the world. It is the second such museum in the world – the State Historical Museum of Religion in St Petersburg being the first –and was founded in 1932.

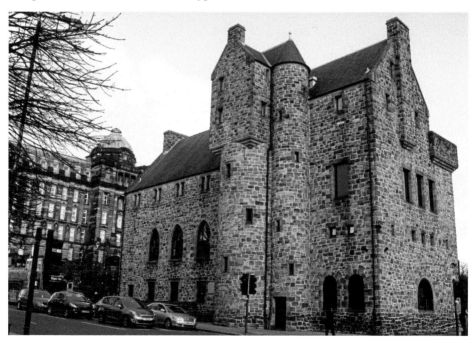

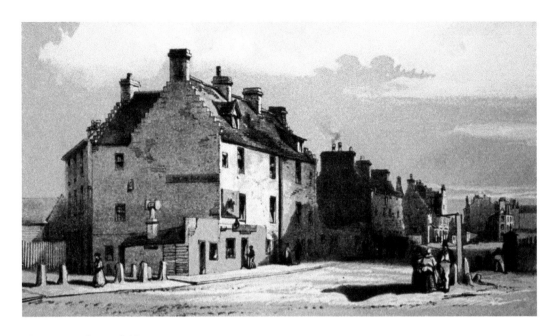

The Provand's Lordship

This is the oldest house in Central Glasgow. In the image above, a lean-to alehouse can be seen attached to the gable wall. Built in 1471 for the chaplain of St Nicholas's Hospital, the Provand's Lordship is now a very interesting museum that sits just across Castle Street to the west of the St Mungo Museum of Religious Life and Art. Mary, Queen of Scots stayed here when she visited her husband, Lord Darnley, who had contracted smallpox and was convalescing in a cottage near the cathedral. Early in February 1567, he was taken to Edinburgh, where he was murdered on the night of 9 February 1567, aged just twenty-one years. Letters to the Earl of Bothwell (the Casket Letters), purported to be from Mary, implicated her in the murder.

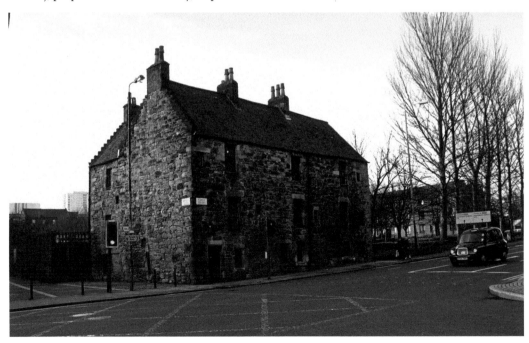

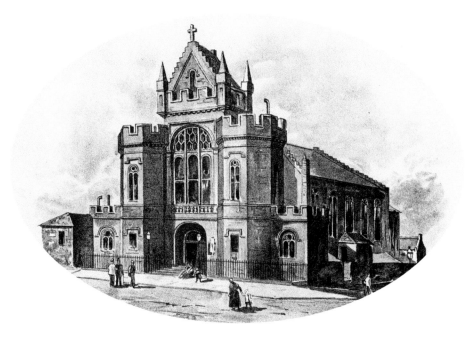

Barony Church, 1798

The original Barony church, designed by James Adam and John Robertson, opened in 1798. Shown above, it was sited just south of the cathedral, with the front elevation facing west. However, the gothic design proved to be unpopular. An architectural competition was launched and the new Barony church, designed by J. J. Burnet and J. A. Campbell, was built in 1890 to the west across Castle Street at a cost of £20,000. In 1984, Strathclyde University bought the building for graduations and other events.

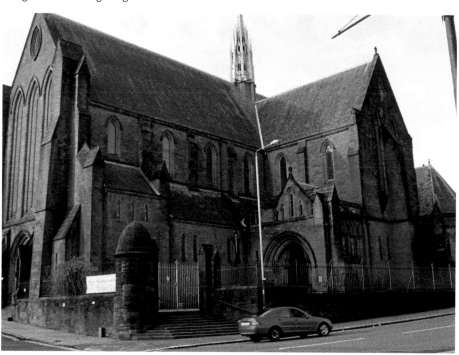

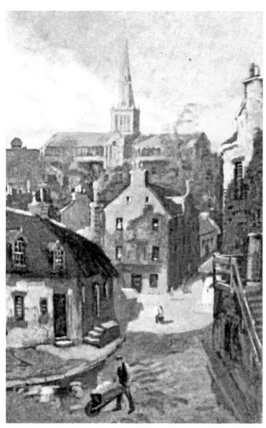

Drygate: Birthplace of James 'Paraffin' Young

Born on 13 July 1811 in Drygate, south of the cathedral, James Young, inventor, entrepreneur and chemist, started studying chemistry part-time at Anderson's College (now Strathclyde University) while apprenticed to his father as a carpenter. His lecturer was Professor Thomas Graham, whose 'Laws of Diffusion' were the basis for many practical uses, including the modern-day artificial kidney machine. Another student at Anderson's College, studying medicine, was David Livingstone. The two became lifelong friends. Young discovered a method for distilling paraffin from coal and shale, which he patented on 17 October 1850. From the sizeable fortune amassed from this patent, Young financed many of Livingstone's explorations and the purchase of the freedom of African slaves from Arab traders. After Livingstone's funeral, Young continued to support the family and to finance the anti-slavery movement.

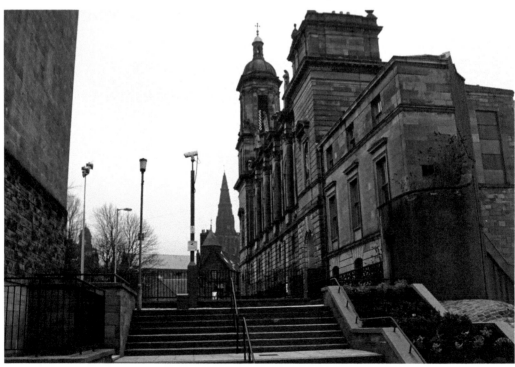

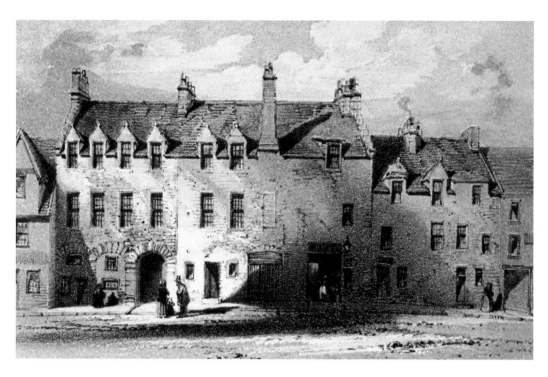

The Duke's Lodgings, Drygate, 1846

James Graham, 4th Duke of Montrose (1799–1874), served as Chancellor of the University of Glasgow between 1843 and 1874. His lodgings would have stood to the right of the picture below.

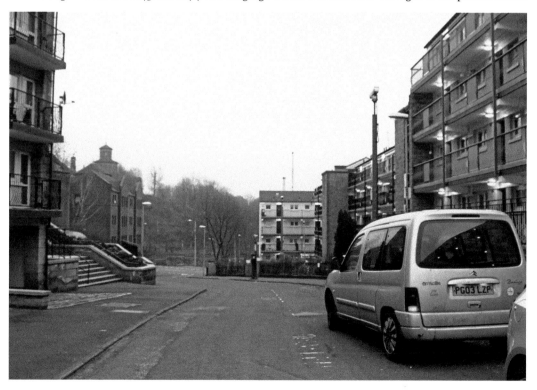

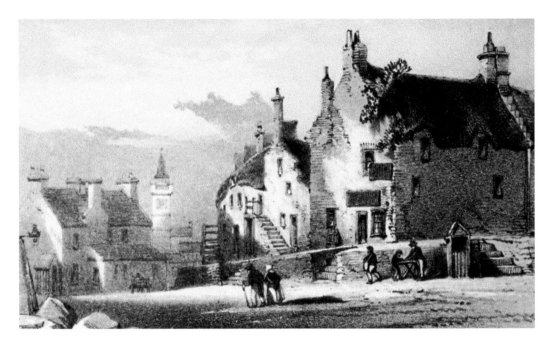

Bell of the Brae: Rescue Attempt

At this point, the police van stopped to turn into the gate of Duke Street prison and supporters of Frank Carty attacked, shooting at the back door in an attempt to free the IRA leader. The door stuck and after the van reached its destination it took hours to get Carty out. Below is the oldest statue in Glasgow, King William III (William of Orange), now sited at Cathedral Square. Previously, it stood at Trongate in front of the Tontine Hotel for 163 years. The tail is on a ball and socket joint and can be seen moving in the wind.

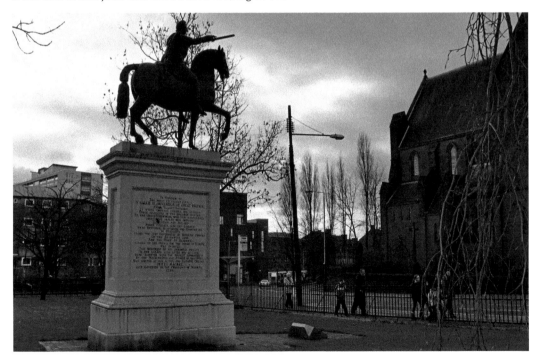

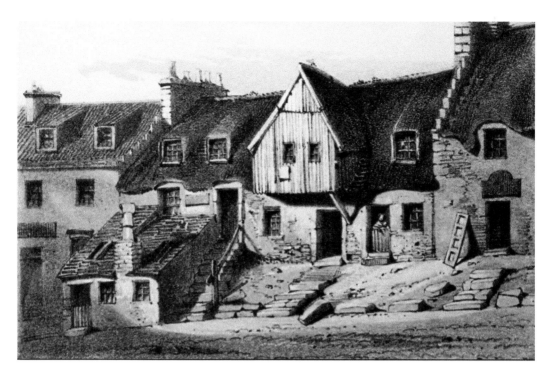

The Battle of the Bell o' the Brae

Here, the English forces, having been advised that William Wallace was on his way to the Bishop's Palace, came out to attack. Wallace, in battle, drew the forces down the hill, allowing his men to close in behind from Drygate in a pincer attack. With this tactic, he defeated the English troops in the Battle of the Bell o' the Brae.

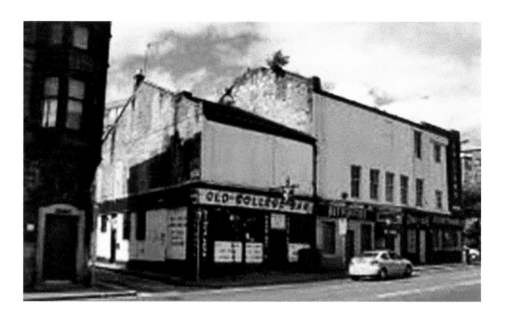

Old College Bar

Some parts of the Old College bar date back to 1515, and it is reputed to be the oldest pub in Glasgow. Its name comes from the fact that Glasgow University used to be situated right across the road. It has traded as a bar, with the same name and in the same building since 1812. Last year, an application was lodged with the planning department for the bar to be demolished. The regulars oppose this. They say that there is a real family atmosphere and that their social life would be brought to an abrupt end were the bar to close. A new bar just would not measure up.

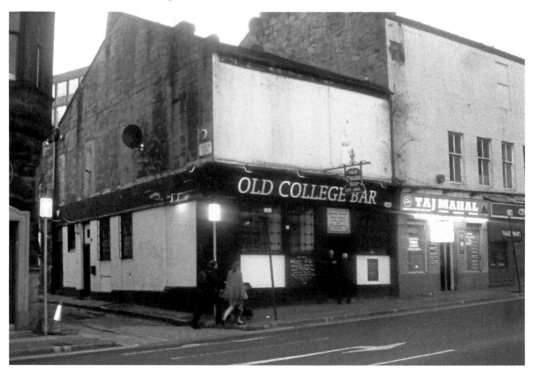

Former British Linen Company Bank

Built in 1895, this lovely little building is now rather neglected. As testified by the writing on the window, a fruit merchant, Robert Bell, once used the ground floor, but this is now derelict. The upper two floors seem to have been residential accommodation. A plaque on the north elevation (*inset*) states that this is the site of the home of the poet Thomas Campbell (1777–1844). A statue of Thomas Campbell, who was friends with Sir Walter Scott, Wordsworth, Coleridge, Byron and Keats, sits in George Square at the south-east corner.

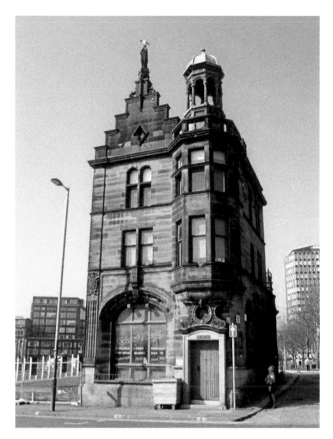

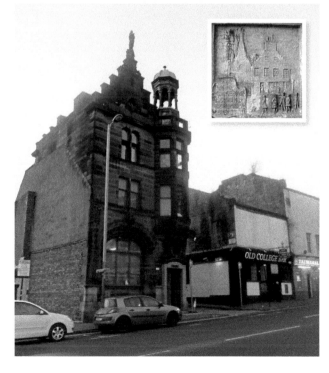

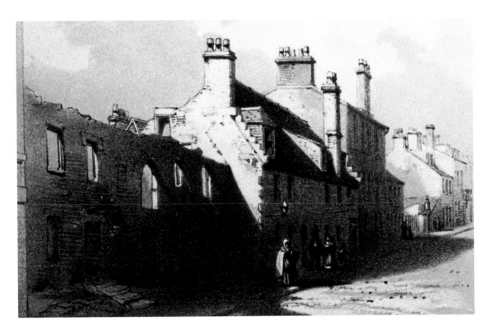

The Auld Pedagogy: Glasgow University, High Street

Founded in 1451 by a Papal Bull from Pope Nicholas V (at King James II's suggestion), giving Bishop William Turnbull permission to have a university at the City's Cathedral, Glasgow University is the second oldest University in Scotland and the fourth oldest in the English-speaking world. Teaching began in the chapter house of the cathedral, but soon moved to the Auld Pedagogy in Rottenrow (seen as a ruin above). In 1563, Mary, Queen of Scots, granted the university 13 acres of land on the opposite side of High Street from Rottenrow, on which was built a university north of Blackfriar's church (the engraving below shows the scene as it was in 1650). The Macfarlane Observatory was built in 1747, then Scotland's first public museum, the Hunterian.

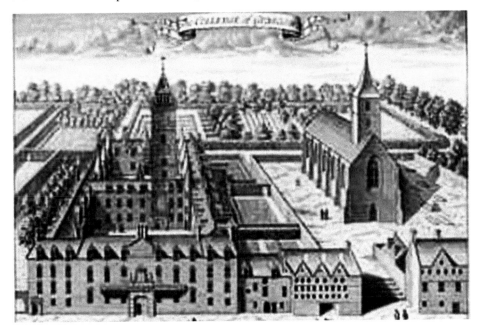

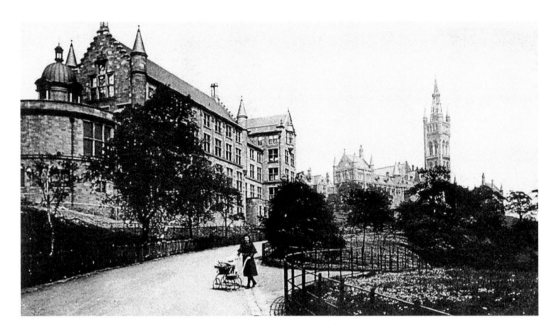

Glasgow University, Gilmorehill

In 1870, the High Street land was sold to the City of Glasgow Union Railway and the university moved 3 miles west to Gilmorehill. The new campus was built by Sir George Gilbert Scott in the Gothic Revival style, the second largest example in Britain after the Palace of Westminster. The new university building commands a wonderfully open aspect looking over the River Kelvin, Kelvingrove Park, the Kelvingrove Art Gallery and Museum and the Kelvin Hall. William Thomson, the famous physicist, professor of Natural Philosophy at Glasgow University from 1846–99, was named Lord Kelvin in honour of his achievements (Second Law of Thermodynamics, temperature scale, marine safety, telegraphy) after the river that flowed past the university.

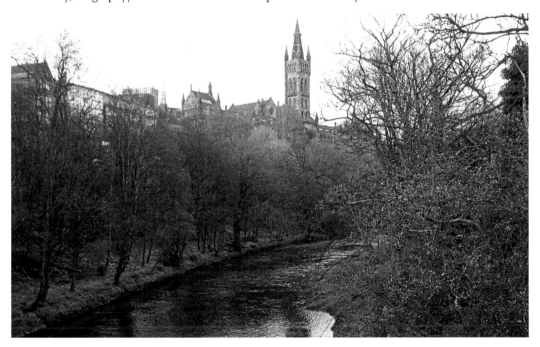

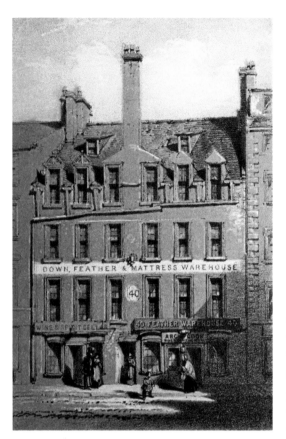

Down Feather and Mattress Warehouse
This must have been big business in those days – there's another similar warehouse right across the road (*see page 23*) near the bottom of High Street. No. 40 is now a single-storey building – McChuill's pub, a well known live music venue. The Fratellis started out and were discovered by their manager here.

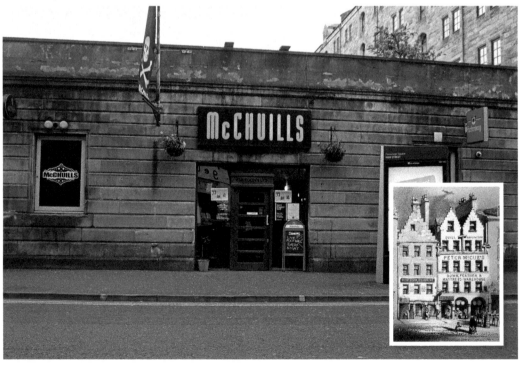

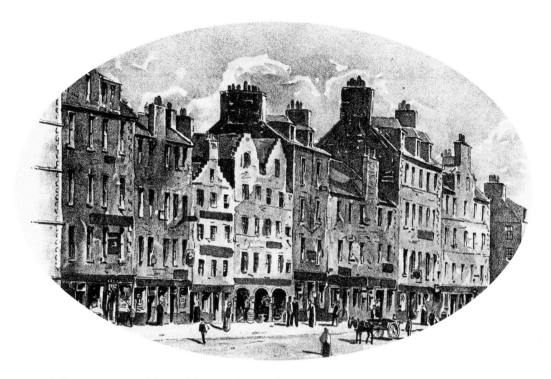

High Street West Side, Looking North to Bell Street

Note the crow-stepped gable buildings. The one on the left is Rob Gould's Tavern and the double-roofed one on the right is Peter McCue's Down, Feather and Mattress Warehouse. In the new photograph below, the blond sandstone building behind the Tolbooth steeple is the Bank of Scotland and one large, red sandstone tenement building has replaced the array of buildings in the top picture. Usually, there would be a lot of traffic here, but this photograph was taken on a Sunday. A lone runner has just crossed the Gallowgate.

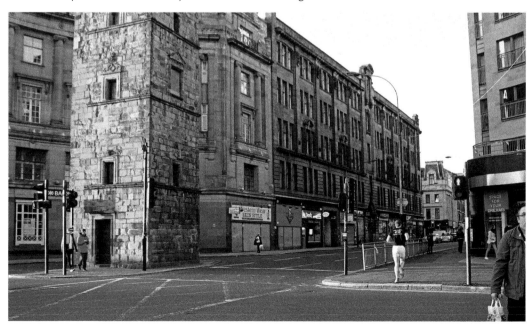

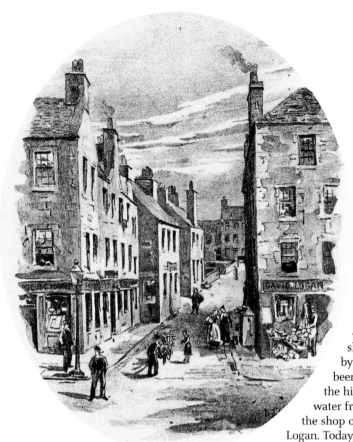

Spoutmouth

In earlier times, comparatively clean water was collected directly from the burn at the top of the hill. The engraving to the right shows Spoutmouth in 1867, by which time a well had been installed at the bottom of the hill and people collected the water from there. The name above the shop on the east side is David Logan. Today, Spoutmouth is a wider road with waste ground on either side.

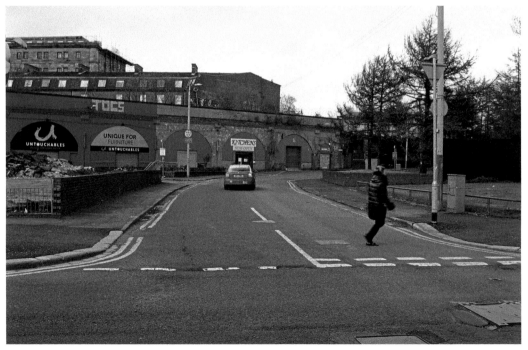

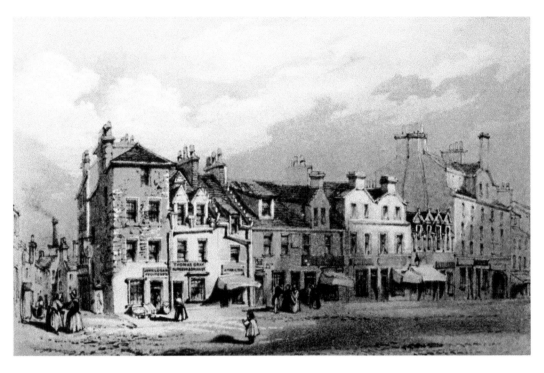

Gallowgate, Looking East

The engraving above shows an assortment of two- and three-storey buildings. The photograph below shows the same stretch of road with three- and four-storey buildings. The gable wall has a mural painted on it to brighten the area – possibly for the Commonwealth Games (July and August 2014).

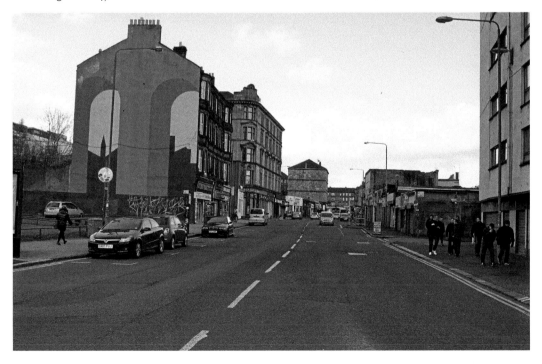

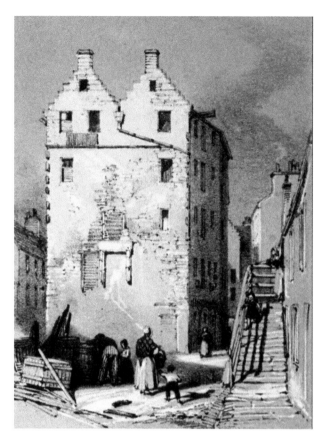

Easter Sugar Refinery

Across the Gallowgate, south of Spoutmouth, was the Easter Sugar Refinery, which would have provided jobs for the people in the area. The new photograph shows that a block of flats has been built on the site of the refinery. Libby's paint and wallpaper shop takes up the whole ground floor of the block facing onto the Gallowgate.

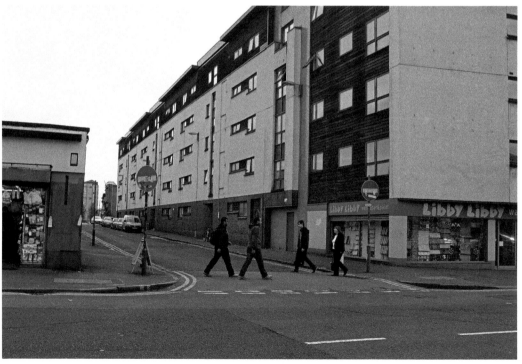

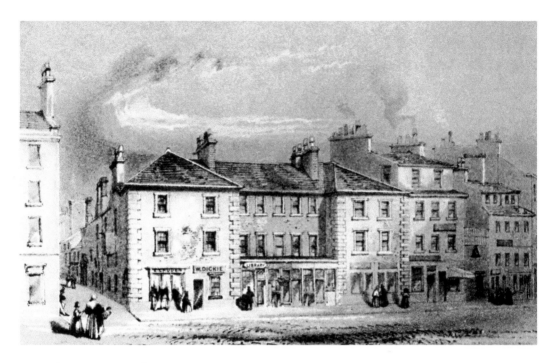

The Saracen Head Inn

The 'Sarry Heid', as it is known to Glaswegians, was built in 1755 by Robert Tennent, the brewer, with stones taken from the demolished Bishop's Palace. It was the first hotel in Glasgow and quite a grand hostelry, with thirty-eight rooms and stabling for sixty horses. In the late eighteenth/early nineteenth century, it was frequented by people like Rabbie Burns, William Wordsworth, Adam Smith, James Boswell and Samuel Johnston. Now, it claims to be Glasgow's first pub-museum, where you can 'see the skull of Maggie, the last witch to be burned at the stake' and 'read a poem in Rabbie Burns' own handwriting'.

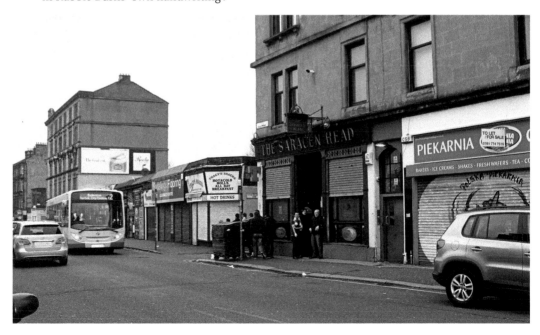

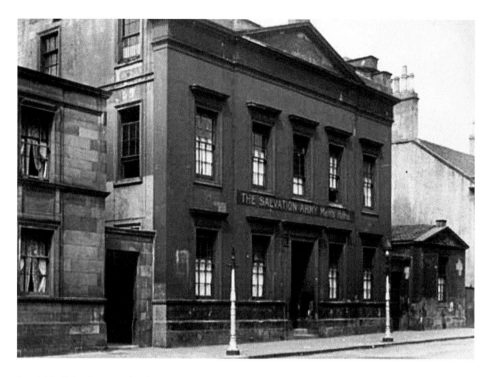

David Dale's House, Charlotte Street, c. 1916

When David Dale lived here, Charlotte Street was one of the most prestigious places to live in Glasgow. Dale, a religious, socialist businessman, set up the New Lanark Mills, where he provided housing, education and even recreational activities for his workers. Both he and his son-in-law, Robert Owen – later credited as founding fathers of socialism and the creators of utopian socialism – were determined to create a model community. They also provided a school for the under-fives, which is now recognised as the first nursery in the world. David Dale died in 1806, and by the time the Salvation Army took over the house for a 'men's home', the area was in deep decline. Below is the Wise Group Head Office, formerly Our Lady and St Francis's Secondary School for girls (1964–89), built on the site of David Dale's house. On the corner to the right stood the Camp Coffee Works, producers of the world's first instant coffee. Today, the last of eight Adam-style houses still stands on the north-west corner. It is now tourist accommodation.

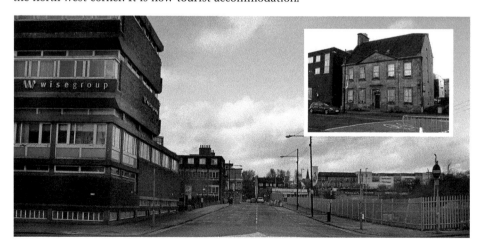

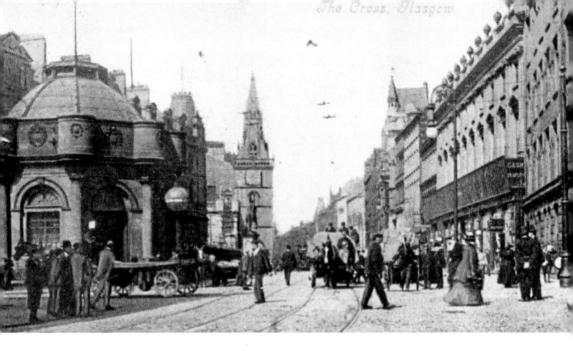

Glasgow Cross, Looking West

In this tinted postcard, posted 29 September 1904, the entrance to the Glasgow Cross railway station can be seen to the left. To the right of this, the statue of King William III faces the steeple of the Tron church. In the centre, an open-topped tram on the left tramline moves westward and a heavily laden horse-driven cart moves eastward. The red sandstone building on the far right is the Tolbooth, and second right is the Tontine Hotel, where the Tobacco Lords and other prominent businessmen used to meet. Below, taken from slightly further east, the Mercat Cross can be seen to the left (not to be confused with the railway station entrance, which was closed in 1964 and subsequently demolished), indicating the central area where the right to hold a regular market was granted and where public events took place.

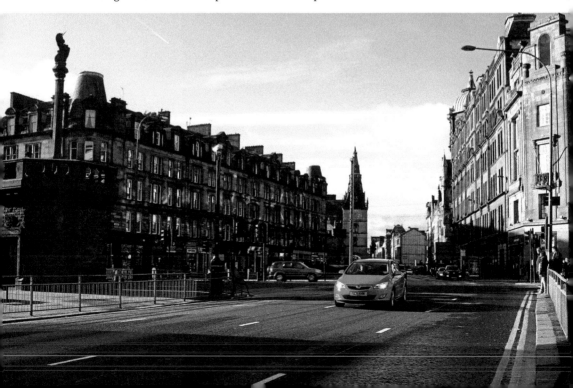

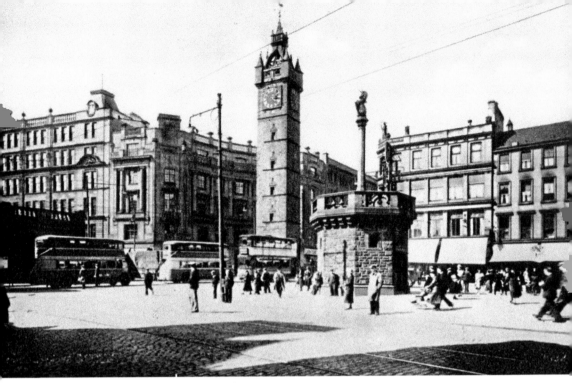

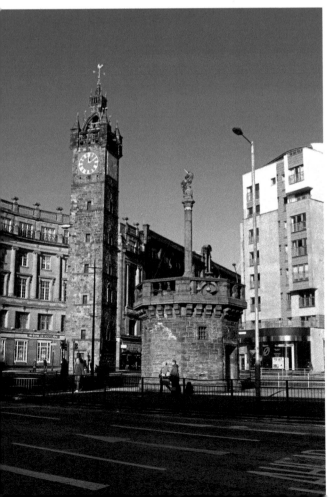

Glasgow Cross From London Road
The tolbooth has been demolished, leaving only the steeple standing on an island in the middle of the entrance to High Street. The new building houses the Bank of Scotland and curves around the steeple. On the right, new luxury flats can be seen at the corner of High Street and Gallowgate. A badge on the eastern side of the Mercat Cross tower reads *Nemo me impune lacessit* – no one provokes me with impunity. This is the motto of Scotland and in Scots it could be translated as 'Wha daur meddle wi' me'. The heraldic unicorn at the top represents a desire for harmony through insight and understanding.

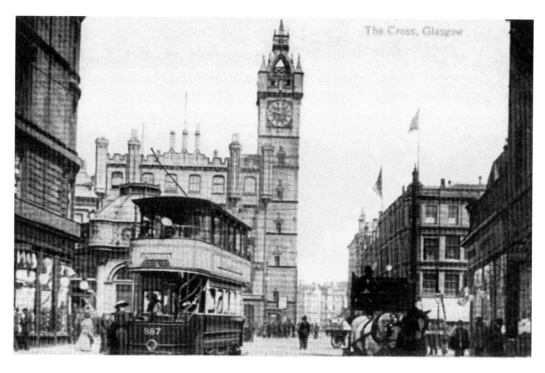

The Cross, Glasgow

Glasgow Cross From Saltmarket, Looking North

The railway station entrance can be seen to the left of the closed top tram and the Tolbooth can be seen behind it. This dates the photograph to between 1900 and 1921. The first standard trams built by Glasgow Corporation Tramways were single-decker trams, after which the old double-decker, horse-drawn, open-topped trams were converted to electrification. The second phase standard tram seen above would have been built at the GCT's own tramway works at Coplawhill in the early 1900s. The Tolbooth was demolished in 1921.

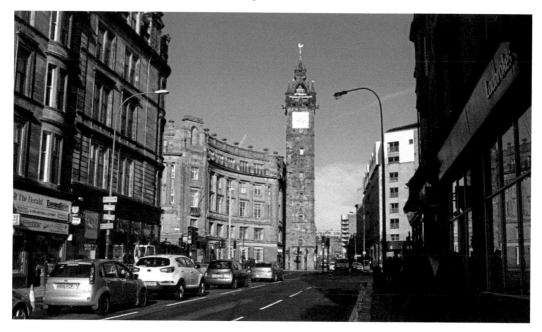

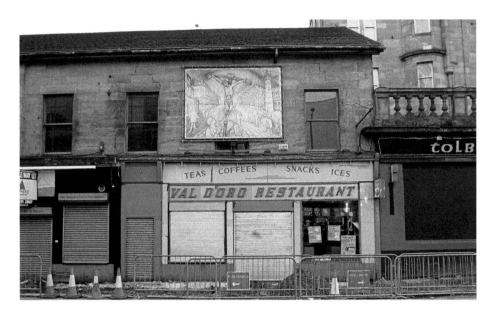

The Passion at Glasgow Cross, Above Val D'Oro Restaurant

In 2010, this large painting (*below*) suddenly appeared on the wall above the Val D'Oro Restaurant on the south east-corner of Glasgow Cross. Painted by David Adams, the brother in law of Luigi Corvi (owner of the Val D'Oro), in honour of the Pope's visit, it depicts Christ on the cross at Glasgow Cross, eyes cast upwards in despair. A small boy is offering a drink of Irn Bru, Luigi (to the left) is holding a fish supper and his father Pietro appears to be showing stigmata. A regular customer, Mary Paterson, is shown with her shopping trolley in which sits her little dog. She has been positioned at Jesus' feet as if representative of the Virgin Mary. The painting has been a talking point for the last four years but now (May 2014) it has been taken down in response to complaints from the regulars who consider it insulting and irreverent. Luigi, Glasgow's Pavarotti, is a trained tenor. He gave up his singing career to look after the family business. However, after years of singing to his customers, he now has a record deal. Good luck Luigi. You deserve it.

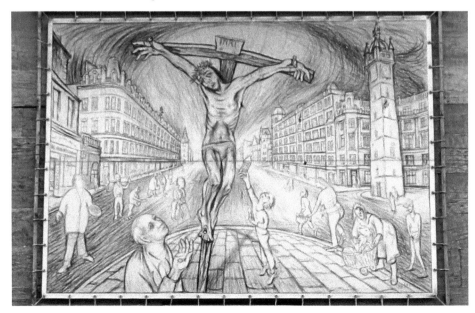

St Andrews in the Square

This former Presbyterian church, the first to be built after the Reformation, was designed by Allan Dreghorn and inspired by St Martin-in-the-Fields in London. Construction began in 1739 and was completed in 1756, making it the third or fourth oldest church in Glasgow, depending on which criterion is used. In December 1745, Bonnie Prince Charlie's army camped on the building site while, of course, he lived in luxury in Shawfield Mansion. The church was commissioned by the city's Tobacco Lords, and when completed it was considered one of the finest classical churches in Britain. Several of Glasgow's wealthiest merchants later came to live in mansions in the square surrounding the church. Agnes McLehose (née Craig), the poet who inspired Rabbie Burns to write 'Ae Fond Kiss', was married here in 1776 to James McLehose. On 23 November 1785, Vincenzo Lunardi spectacularly ascended from the churchyard in his pink, green and yellow silk hot-air balloon to the delight and astonishment of the Glaswegian spectators. Several items of female clothing were named after him, including the Lunardi Bonnet, mentioned by Burns in 'To a Louse', which was designed in the shape of a balloon about six centimetres high. In 1993, the church was sold to the Glasgow Preservation Trust for £1 and the subsequent renovation has won several awards. It is now a Scottish Cultural Centre and a lovely venue to hire for special occasions.

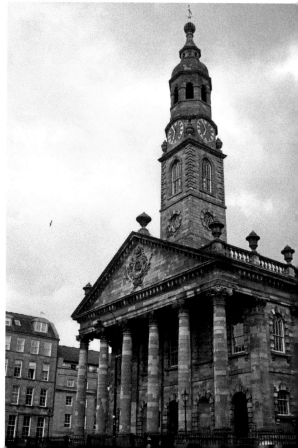

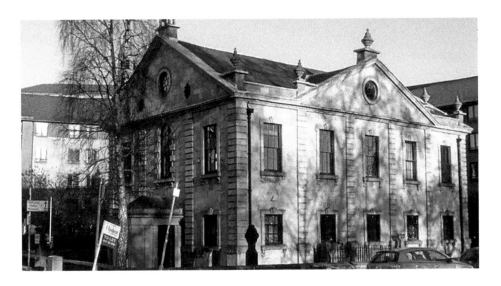

The Whistlin' Kirk

St Andrews-by-the-Green, on the corner of Turnbull Street and Greendyke Street, was the first Episcopalian church to be built in Scotland after the Reformation. Started in 1750 and completed in 1751/52, it is, like St Andrews-in-the-Square, either the third or fourth church to be built in Glasgow, the other two being the cathedral and the Tron. The designer, Andrew Hunter, was excommunicated from his Prebysterian church for producing the work. It was nicknamed the 'Whistlin' Kirk' because it was the first church in Glasgow to install an organ for public worship. Built by John Snetzler in 1747, and enlarged by his pupil, John Donaldson of York, in 1788, the organ was eventually sold to the Glasgow Unitarians' new chapel in Union Street and moved with them to their new place of worship in St Vincent Street in 1856. When this church was demolished in 1982, the organ, now the oldest in Glasgow, was donated to the University of Glasgow. The congregation of the 'Whislin' Kirk' dwindled and the building was sold in 1985 for office accommodation. A major fundraising effort, supported by the late John Crichton-Stuart, the 6th Marquess of Bute, raised the £600,000 required to renovate the building. Since 2003, it has been the headquarters of the Glasgow Association for Mental Health.

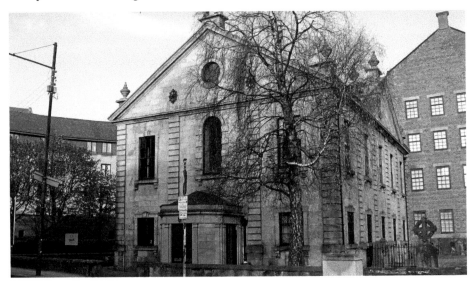

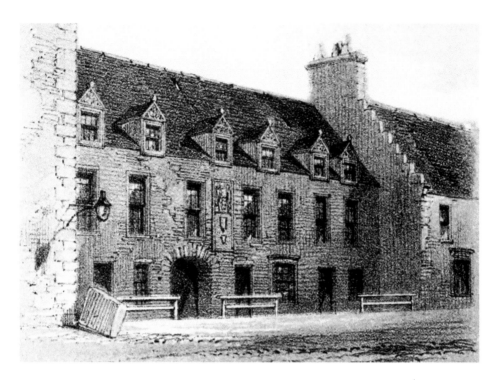

Silvercraig's Land

Located at the south-east corner of Saltmarket, Silvercraig's Land was built in 1640 by Robert Campbell of Silvercraigs, son of Colin Campbell of Blythswood. It was used by Oliver Cromwell as his headquarters during his visit to Glasgow in 1650. The mansion stayed in the Campbell family until 1703, when it was converted for use as a furniture warehouse. Later, it was used by the MacGilchrist family, probably as a weaving factory. Today, the site is occupied by a block of flats.

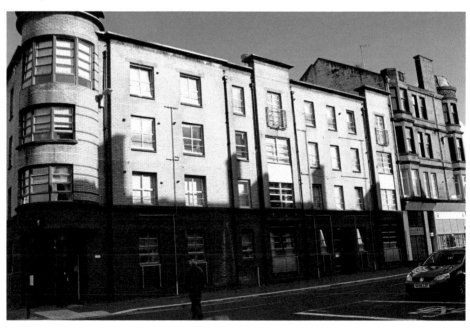

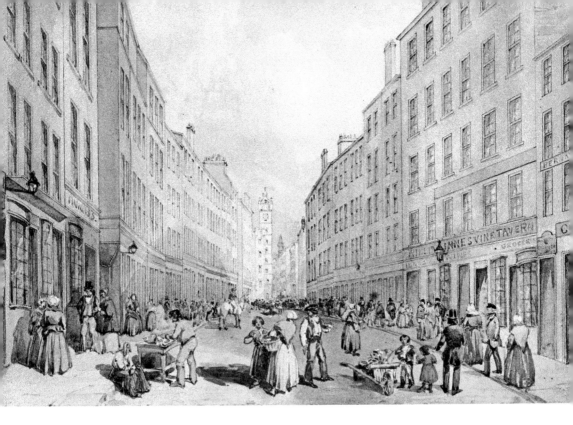

Saltmarket, Looking North

Above is an old watercolour by Alexander Shanks showing life in the Saltmarket in 1849. Note that there are no tramlines yet, just a solitary horse and rider. The Tolbooth can be seen in the middle of the picture at Glasgow Cross and two taverns are shown, one on each side of the road. Gas lamps are attached to the buildings. Several men can be seen in top hats, a few in caps and the women are all well covered, with not even an ankle to be seen. Below, the railway bridge can be seen spanning the Saltmarket near Glasgow Cross. Modern cars replace the horse as the means of transport.

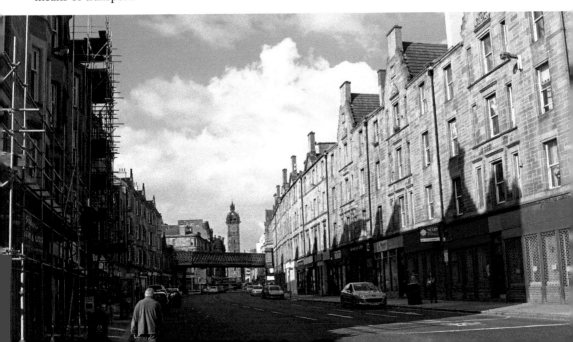

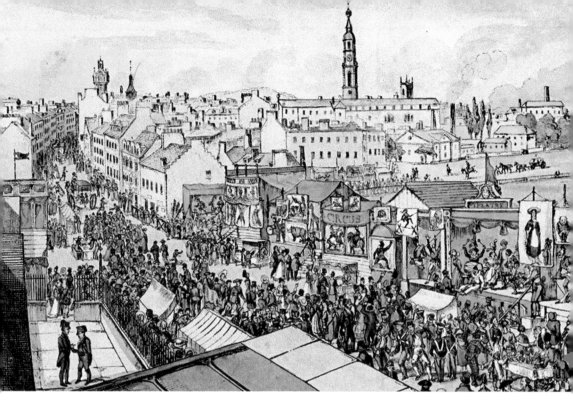

Glasgow Fair at Jocelyn Square

During Glasgow fair fortnight, 'the shows' (funfair), including a circus, used to come to town for the last two weeks of July. This was when all the factories were closed for the summer holiday. The image above shows the area at the bottom of the Saltmarket between the High Court and Glasgow Green, showing booths offering all sorts of entertainment. The shows got bigger every year until, by the mid-1950s, the fair was no longer in Jocelyn Square but instead covered several acres of Glasgow Green. The circus, held in a huge marquee erected just for the two weeks, was always sold out. The acts consisted of trained elephants, lions and seals, high-wire acrobats, bareback riders and clowns – all introduced by the very swish ringmaster in his black trousers, red coat-tails and shiny black top hat. Below is Jocelyn Square in more sombre mood. This area is named after Bishop Jocelin, who was instrumental in freeing Glasgow from the subordination of the Archbishopric of York and from the terms of the Treaty of Falaise. He was a great literary patron and commissioned the *Life of St Kentigern*, the *Life of St Waltheof* and the *Chronicle of Melrose*. At his request, King William also granted Glasgow the right to hold a weekly market and an annual fair.

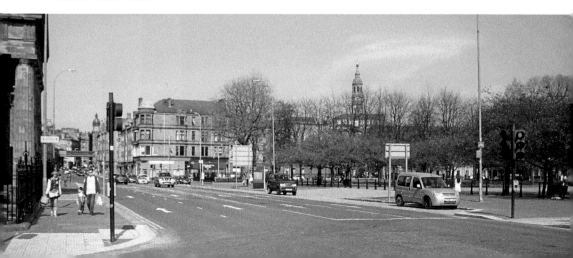

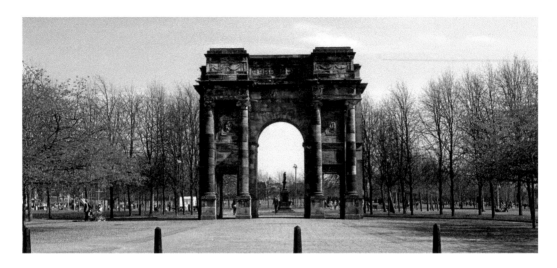

You'll Die Facing the Monument

This was a saying in Glasgow, meaning, 'You'll be hanged for your sins.' The monument referred to is Nelson's monument in Glasgow Green, and the place of public execution was around the site where Jocelyn Square meets Glasgow Green – in fact, around where the McLennan Arch now stands (*see above*). The McLennan Arch used to adorn a window at first-floor level in the front façade of the Assembly Rooms in Ingram Street. It is named after Baillie James McLennan, who donated it to the city. Part of a murderer's sentence was that his body was to be donated to the university for dissection. Only one carter, known as 'Rabination', would undertake the task of transporting the bodies up the Saltmarket to the university in the High Street. The last public hanging in Glasgow was that of Dr Edward William Pritchard in 1865, who had poisoned his mother-in-law and his wife with antimony. Below, Glasgow Green looking west. Nelson's monument can be seen top right, along with a tree-lined road leading west to the McLennan Arch. To the left of the monument, at the perimeter of the red blaise, sits a large boulder commemorating the spot where James Watt had his idea about improving the Newcomen steam engine. His statue also stands in the middle of a red Blaise circle (*bottom right*).

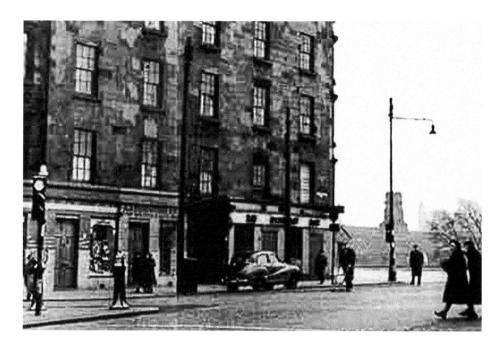

The Clutha Bar

Voted one of the top three live music pubs in Glasgow, The Clutha bar was packed with customers enjoying the music on 29 November 2013 when a police helicopter crashed into the roof, killing ten people: the three crew members, David Traill, PC Kirsty Nelis and PC Tony Collins; and seven customers, Gary Arthur, Samuel McGhee, Colin Gibson, Robert Jenkins, Mark O'Prey, John McGarrigle and Joe Cusker. The Glasgow people were praised for their response, pitching in to help out where they could with no thought for their own safety. A recent report states that the accident could have been caused by double engine failure due to a faulty fuel supply, despite the fact that there was plenty of fuel on board. The top photograph shows the bar in the '60s – then called the Popinjay – on the ground floor of a four-storey tenement block. The bottom photograph shows the hole in the roof and people paying their respects.

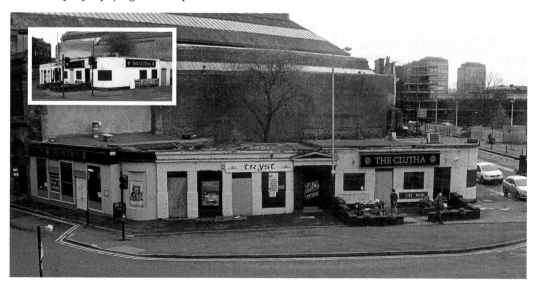

Campbell of Blythswood's Town Residence

This mansion house once had extensive grounds on the south side stretching all the way down to the River Clyde. It was built by Provost Colin Campbell around 1669/70, who left here *c.* 1720. His country home was Renfield house and estate, west of Braehead, which he had purchased in 1664. He later purchased the Blythswood estate in Glasgow. His town house was later split up and used by various trades until it was demolished to make way for the Union Railway's tracks going to St Enoch station. The artist's view above represents the building as may have been around the end of the eighteenth century. Today, ground floor units are let out to various traders.

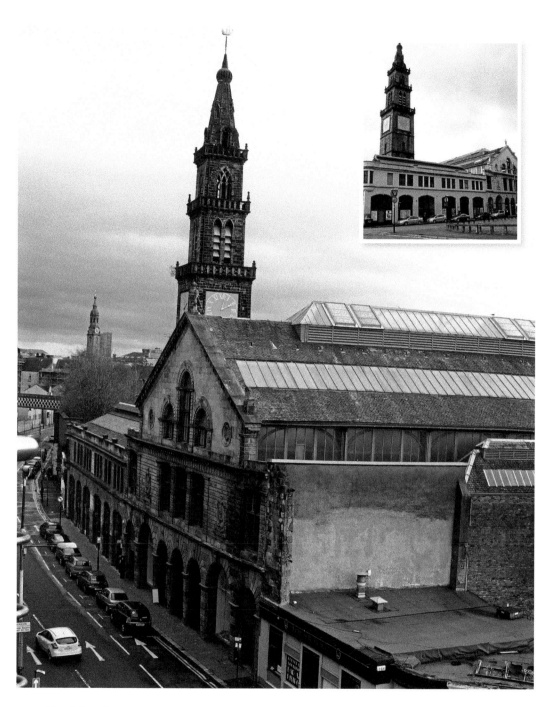

The Briggait

Built in 1873, the Briggait was the city's fish market until the late 1970s. The building was then opened as a shopping mall with various niche market retailers, but that was short-lived. The photograph above was taken when the building was lying derelict in 2008. It was then refurbished and reopened in August 2010 as an arts and cultural centre. Part of the cultural programme during the Commonwealth Games will be held in The Empire Café from 25 July to 1 August 2014.

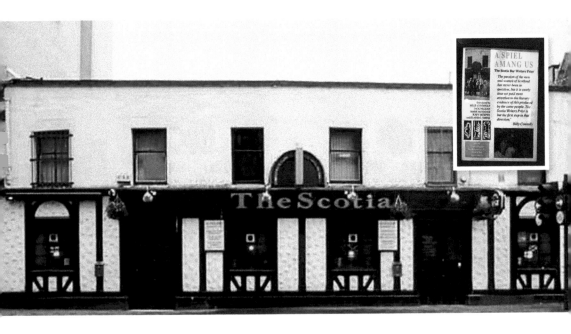

The Scotia

Situated near the south-west corner of Stockwell Street, the Scotia Bar, established 1792, also lays claim to be Glasgow's oldest pub. However, it seems that the dispute for that title between this pub and the Old College Bar will soon be at an end. The planning application for the Old College Bar to be demolished will almost certainly be accepted. The Scotia is a very popular live music venue, as evidenced by the busy programme to be found on its website. It is also very popular with writers and regularly runs writing competitions where the authors read out their work over several heats. There is a poster inside the pub with Billy Connolly promoting this (*see inset above*). Mary Rafferty, the landlady, is very welcoming and regularly and randomly produces delicious free sandwiches for her customers (*see inset below*).

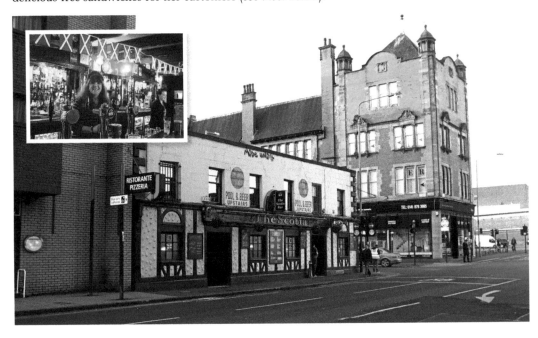

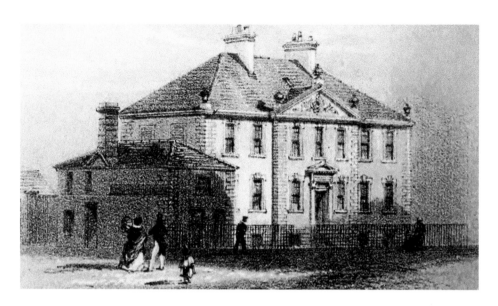

Robert Dreghorn's House

'Bob Dragon', as he was called locally, was a very wealthy and eccentric character. His nickname came from the fact that his face was full of pockmarks from having smallpox as a child. Also, his nose was bent to one side, almost lying flat against his face. Parents used to threaten their children, 'If ye don't behave, Bob Dragon'll come and get ye.' Although he didn't work, he would dress in his fine clothes every day, mix with the merchants at the Tontine Hotel and stride up and down the Trongate following any young lady who took his fancy, then he would do a sudden about turn when he spied someone prettier. He never approached any of the girls and they took it as a compliment. He committed suicide on 19 November 1804, after which the locals thought the house was haunted by his ghost. Eventually, a house painter took on the tenancy. Locals peeking through the windows saw red paint and thought it was blood. This was at the time when grave-robbing was at its height. A mob attacked, throwing furniture into the Clyde. The perpetrators were caught and the one deemed to be the ringleader, John Campbell, was publicly whipped on the back of a cart through the town – the last time this punishment of 'whipping at the cart tail' was used in Glasgow.

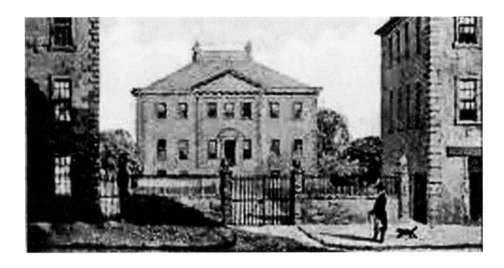

The Shawfield Mansion

Built in the early 1700s at the corner of Trongate and the site now known as Glassford Street by Daniel Campbell of Shawfield, MP for the Glasgow District of Burghs, the Shawfield Mansion was considered in its day to be the grandest house in Glasgow. Already unpopular with Glaswegians, when he voted in favour of the malt tax, they rioted, causing great damage to the Shawfield Mansion. Campbell claimed compensation from the government. He was awarded over £6,000, which Glasgow had to pay. This was an enormous sum at the time, from which Campbell bought the islands of Islay and Jura. In December 1745, Bonnie Prince Charlie commandeered the house and resided there while in Glasgow. Here he fell in love with Clementina Walkinshaw, who later lived with him in France and bore him a child. In 1760, John Glassford, one of Glasgow's wealthiest Tobacco Lords, bought the mansion for 1,700 guineas. In 1792, his son sold the house and grounds to a builder for £9,850.

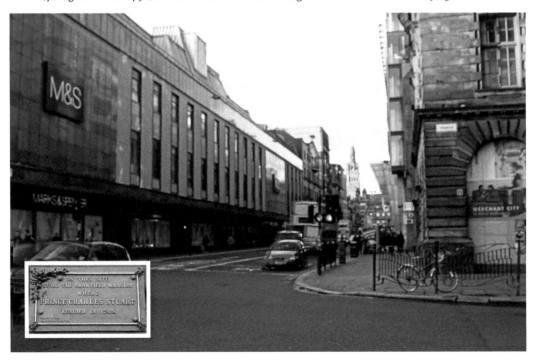

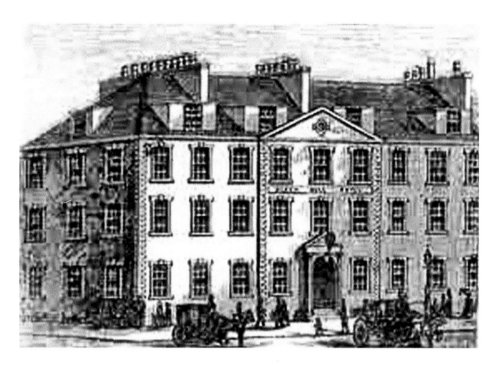

Black Bull Hotel

Situated on the north side of Argyle Street (or Trongate as it was then) between Virginia Street and Glassford Street, the Black Bull Inn, built around 1759 by the Glasgow Highland Society, was an important stagecoach post and hostelry. Here Robert Burns resided from 1787 to 1788.

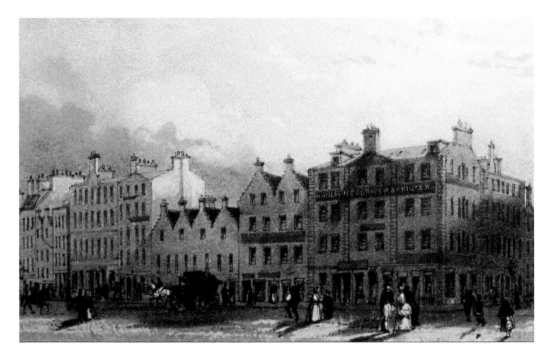

Charlie's Stables

The houses on the south side of the Trongate, east of Stockwell Street, were nicknamed 'Charlie's Stables' because Bonnie Prince Charlie's horses were stabled in their outhouses. The Prince was not popular with the Glasgow people and his demands for clothing and food for his men and stabling and food for the horses didn't help. These houses were demolished in 1838. A Tesco supermarket, a Poundland store and Specsavers now occupy the site.

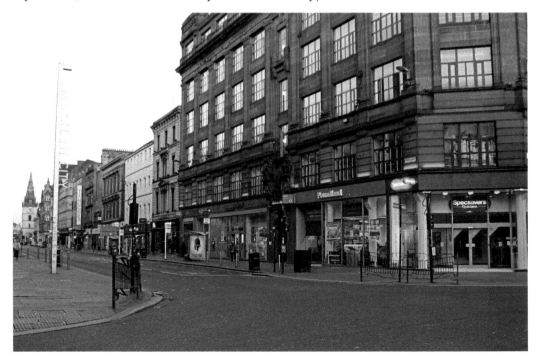

The Panopticon

The Britannia Music Hall on the south side of the Trongate is the oldest surviving music hall in the world. It was built in 1857 by Thomas Gildard and H. M. McFarlane, and in 1906, Stan Laurel made his debut there on an amateur night. Also during that year, A. E. Pickard bought the building and changed its name to The Panopticon. He made some major changes, including excavating the basement in order to install an indoor zoo. It was one of the first buildings in Glasgow to have electricity installed and one of the first cinemas in Scotland. It was sold in 1938 to a tailor who used it as a workshop. Archaeologist, Glasgow historian and music hall enthusiast Judith Bowers is currently striving to bring The Panopticon back to its former glory.

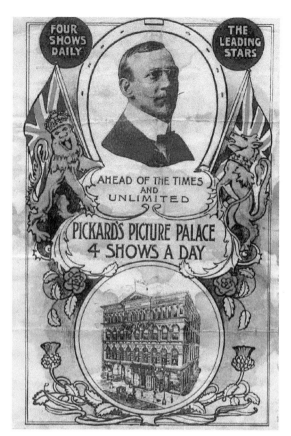

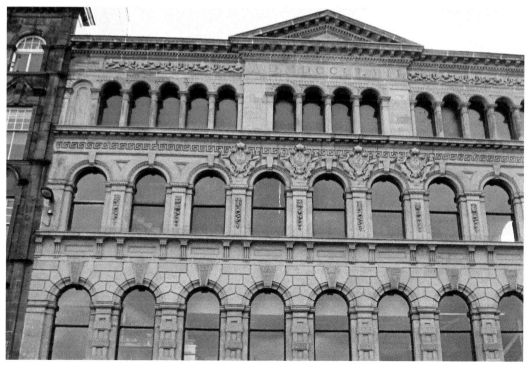

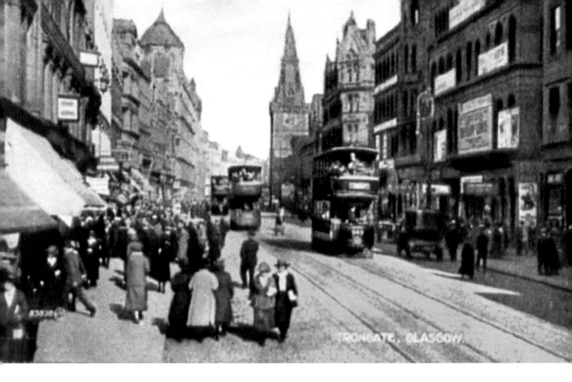

Trongate, Looking East

In the top photograph, The Panopticon can be seen on the right, with billboards all over the front advertising what's on. A car is parked on the right and closed top tramcars are seen travelling in both directions. The ladies' skirts are just above ankle length, and note they are all wearing hats. In those days, it was deemed very improper to go out without a hat. The Tron church is in the centre and the Tontine Hotel is across the road to the left. Below, the Tron steeple can be seen on the right but it is no longer a church, it is part of the Tron theatre and bar. A bus, the current mode of public transport, replacing the tramcars, can be seen stopped at the lights. Note that all of the women are wearing trousers and there's not a hat to be seen. This is unusual as hats are now back in fashion.

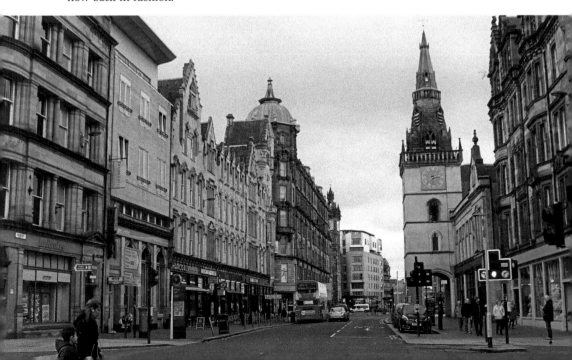

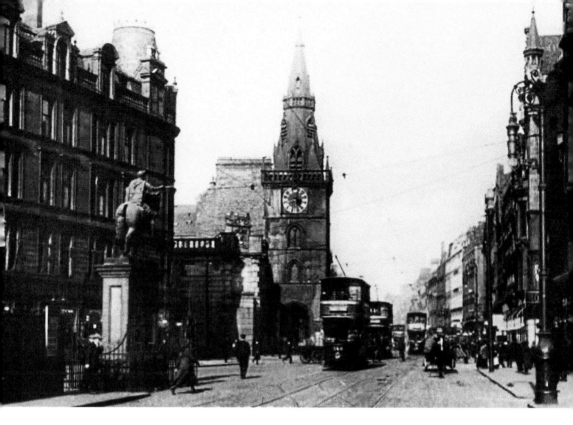

Trongate, Looking West

The statue of King William III on the left of the photograph above is standing on an island in the middle of the Trongate, facing west. At the east end of the island is the entrance to the Glasgow Cross station. When the station was closed, the entrance was capped and the statue was moved to Cathedral Square. The Tron church is now a theatre and bar.

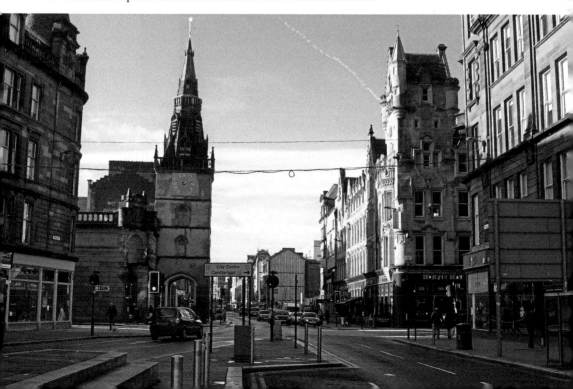

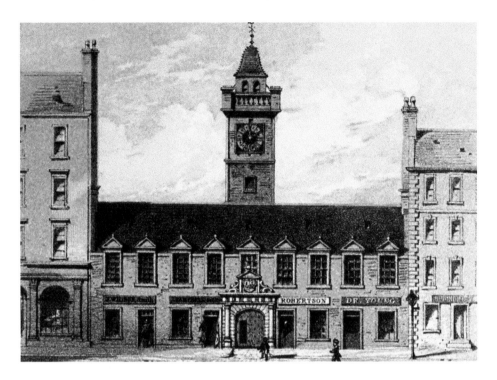

Hutcheson's Hospital

The original Hutcheson's Hospital (built 1641–50) was situated on the north side of the Trongate. George Hutcheson, notary, banker and philanthropist, left money in his will for a hospital to be built for 'poor old men'. His brother Thomas, lawyer and philanthropist, added money to this to include a school for 'poor boys', so Hutcheson's Grammar School was born. It operated in the Trongate until the hospital was demolished in 1795 to make way for Hutcheson Street. Statues of the brothers, which had been on the north-facing wall overlooking the gardens, were put into storage in the Merchant's House. The new building was sited on Ingram Street at the top of Hutcheson Street, and the two statues were built into niches on the south-facing wall. For a while, this building was home to the Stirling Library and the Glasgow Savings Bank. Eventually, the National Trust for Scotland bought it and used it as their headquarters. It is now being renovated and will soon be opened as a restaurant.

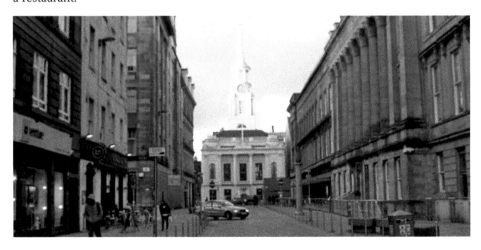

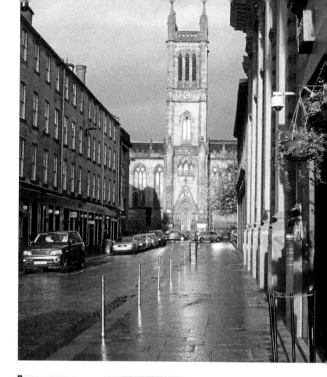

Ramshorn Kirk

Designed by English architect Thomas Rickman, the kirk, built in 1826, was originally known as St David's parish church. Many of Glasgow's wealthy merchants were buried in the graveyard here in Ingram Street. When the street had to be widened, some of the graves had to be moved to the rear of the kirk. Pierre Emile L'Angelier, believed to have been killed by Madeleine Smith (granddaughter of the architect David Hamilton), lies buried here. The film *Madeleine* was made about the case in 1950, directed by David Lean. The University of Strathclyde bought the building and opened the Ramshorn Theatre there on 10 April 1992. It was officially named by Scotland's poet laureate and playwright Liz Lochhead.

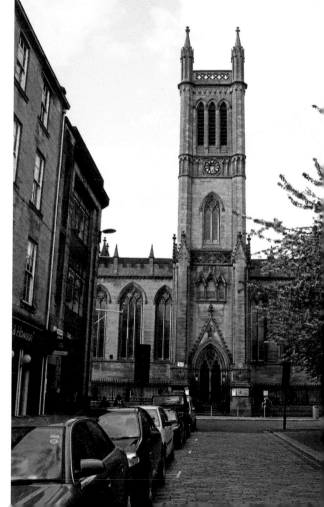

Rottenrow Maternity Hospital

In 1888, Murdoch Cameron became world famous after performing his first Caesarean section here using modern antiseptic conditions. Both patient and baby survived. Ian Donald, Professor of Midwifery at Glasgow University revolutionised medical diagnostics when he, together with fellow obstetrician John McVicar, demonstrated the image of an unborn foetus in the paper 'Investigation of Abdominal Masses by Pulsed Ultrasound', using a machine cobbled together by Tom Brown, an engineer working at the Glasgow firm Kelvin Hughes. Sited at the corner of Montrose Street and Rottenrow, the maternity hospital serving most of Central and Eastern Glasgow became outmoded. Montrose Street, one of the steepest streets in Glasgow, was known as 'Induction Hill' because the nurses would take the pregnant women for walks up and down the hill to induce labour. A new state-of-the-art maternity wing was built at Glasgow Royal Infirmary in 2001 and the old Rottenrow building was sold to Strathclyde University. It was demolished, leaving only the original portico entrance, which now forms a feature at the northern end of Rottenrow Gardens.

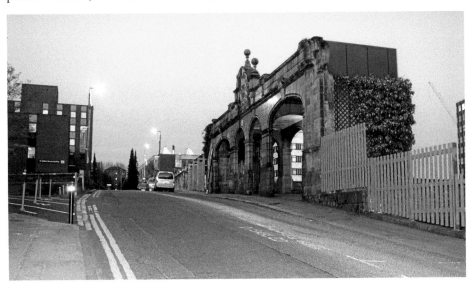

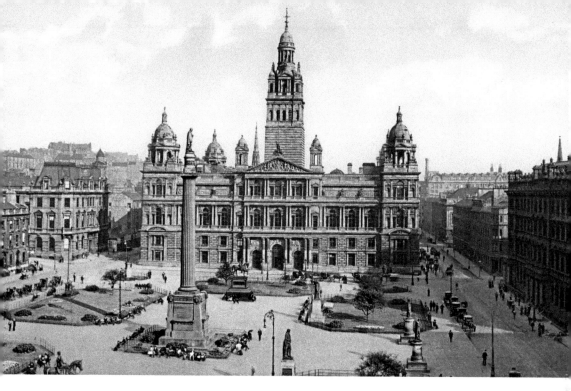

George Square Looking East

The tall statue in the middle is a memorial to Sir Walter Scott. Looking past the statue, the City Chambers can be seen (built 1882–89). A competition was held for the design of the building, and architect William Young of Paisley (who trained in Glasgow) won with his Beaux-Arts design. The exterior sculptures were crafted by James Alexander Ewing. His figure, representing 'Truth' in the group 'Truth Honour and Riches', is known as Glasgow's Statue of Liberty, due to the fact that her stance is very similar to the New York statue – but it is a lot smaller. The Cenotaph, designed by Sir J. J. Burnet and Norman Dick, and sculpted by Ernest Gillick, now stands centrally positioned at the east end of the square in front of the City Chambers.

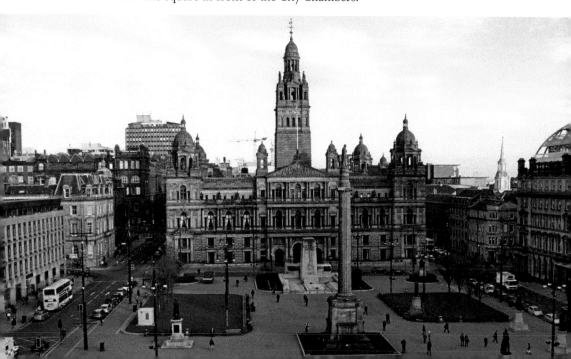

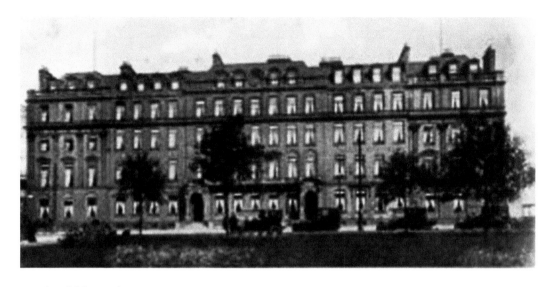

North British Hotel

This impressive building at the north side of George Square was erected in 1807 as three townhouses. One famous resident was Sir William Burrell, a wealthy shipping merchant who bought No. 47 in 1862 and made it his home. He bequeathed his vast and very valuable art collection to the city of Glasgow. In 1878, the three townhouses were converted to hotels – the Queen's Hotel, the Royal Hotel and the Crown – and around twenty years later these three hotels were bought by the North British Railway and amalgamated to become the North British Hotel. Churchill held a meeting here in January 1941 with Franklin D. Roosevelt's special envoy, Harry Hopkins, which resulted in America joining forces with Britain against Hitler. Today, a meeting room in the hotel (now called the Millennium Hotel) is named after Harry Hopkins.

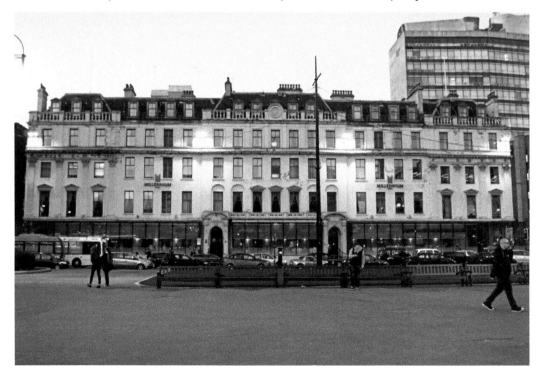

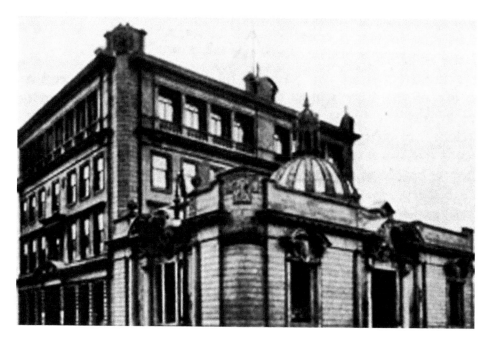

Glasgow Savings Bank

This building, at the corner of Glassford Street and Ingram Street, was the home of the Glasgow Savings Bank from 1836 to 1976. Alexander Grey, a Glasgow accountant, campaigned for this bank, believing that it would help the poor to save. The first office was in Hutcheson's Hall/Hospital, but offices quickly opened across the city, staffed by volunteers and opening only one day a week, often for just a couple of hours. By 1938, there was a network of offices across the west of Scotland. In 1976, Glasgow Savings Bank became part of the West of Scotland Trustee Savings Bank. The building is now being used by Jigsaw, a clothing retailer.

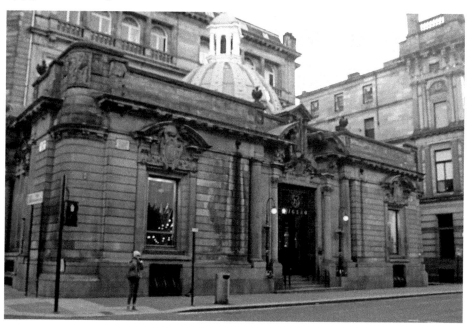

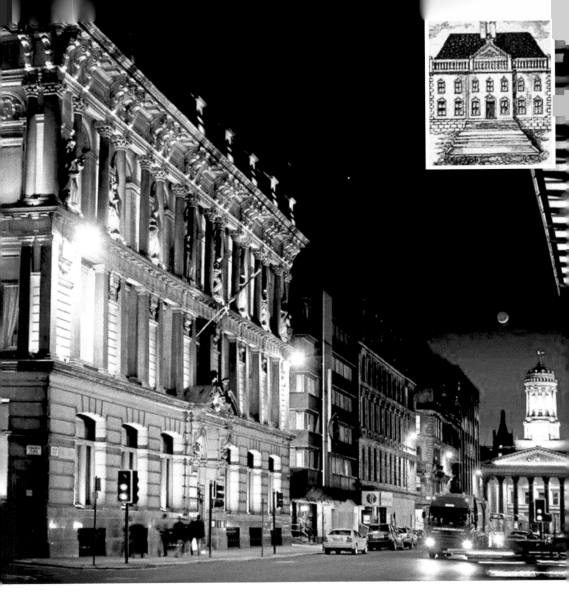

The Corinthian Club

Originally, the Victoria Mansion (*see inset*) was built on this site by George Buchanan, a wealthy Tobacco Lord, on land bought by his father, Provost Andrew. Buchanan laid out garden grounds to the south of the mansion and built a street, which he named Virginia Street, leading from the gate to Argyle Street. The mansion was sold to Alexander Speirs of Elderslie in 1770, then it was owned by a succession of wealthy merchants until demolished in 1842 to make way for a bank. First a bank, then the High Court, this building has been refurbished to a very high standard by Stefan King's G1 Group. The award-winning interior of the Corinthian on Ingram Street is really worth seeing. The club caters for meetings, corporate events, weddings and other events. and they have a piano bar and casino if you just want to have a drink, maybe a flutter, and enjoy the beautiful surroundings. The Gallery of Modern Art can be seen to the right of the photograph on the corner of Ingram Street and Queen Street.

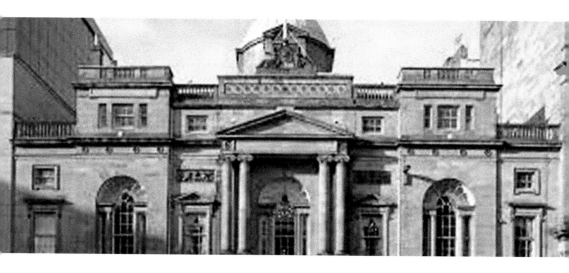

Trades Hall

The second oldest building in Glasgow (after St Mungo's Cathedral) is still being used for its original purpose. The Trades Hall is home to the Trades House and the fourteen incorporated trades, namely hammermen, tailors, cordiners, maltmen, weavers, bakers, skinners, glovers, wrights, coopers, fleshers, masons, gardeners, barbers, bonnetmakers and dyers. The Trades House of Glasgow incorporated by Letter of Guildry in 1605 is an elective body consisting of representatives chosen from each of the Fourteen Incorporated Trades or Craft Guilds of the City of Glasgow. Initially, this body held meetings in the Laigh Session House of the cathedral. Its first charitable act was to complete an existing scheme, started by some of the member guilds, to create an almshouse at the corner of High Street and Cathedral Street, where the Trades House later held its meetings. By the end of the eighteenth century, it was decided that the greater good would be met by closing the almshouse and distributing 'outdoor relief' to the poor – an early version of 'care in the community'. In 1791, Robert Adam was commissioned to design the present-day Trades Hall. Thought to be one of his finest designs, it was eventually completed by his brothers in 1794, two years after Robert's death.

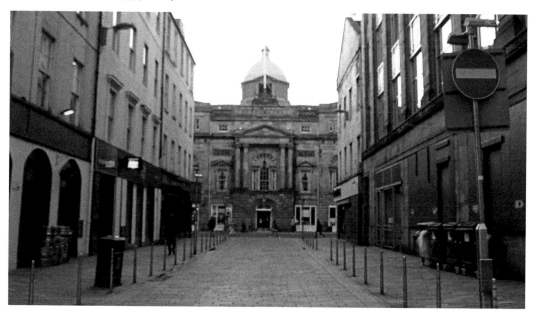

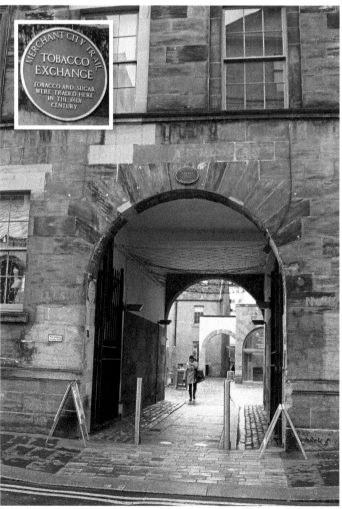

Virginia Street

This is the street laid out by George Buchanan. The tobacco exchange was located at the northern end of the street near where his gate would have been. Very good planning on his part – just a short step to work.

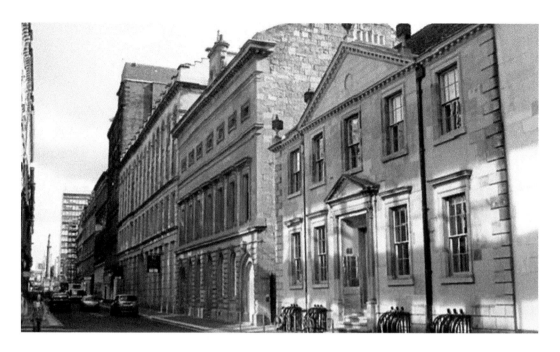

The Tobacco Merchant's House: No. 42 Miller Street

This is the last of the tobacco merchants' houses still standing in the Merchant City. It was built by John Craig (wright) for his own use in 1775, but in 1780 he sold it to Robert Finlay, a tobacco importer, who lived there for the rest of his life. It is a smaller house than the tobacco lords' houses in the Merchant City but comparable with the Adam-style houses in Charlotte Street, David Dale's excepted. The house was bought in 1995 by the Scottish Civic Trust, who restored it and now use it as offices. The building to the left of the Tobacco Merchant's House is where the Stirling Library originated. It is now housed in the basement of the Gallery of Modern Art in Queen Street.

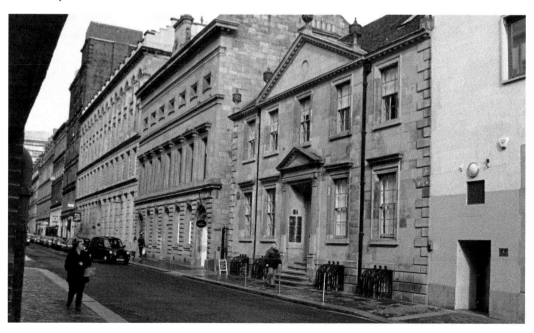

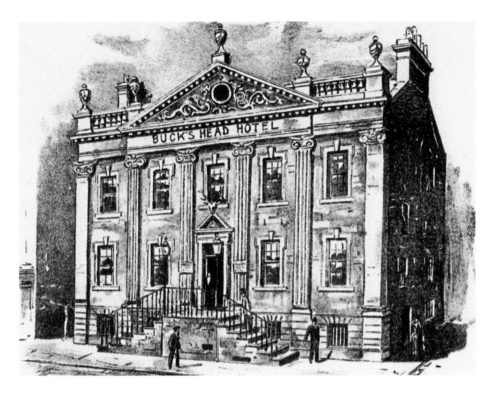

Buck's Head Hotel

In 1757, Provost John Murdoch built a large mansion house at the eastern corner of Argyll Street and the street that was to become Dunlop Street. Another identical one was built to the east of it by Colin Dunlop. In 1790, Murdoch's widow sold the property to Colin McFarlane, who converted it to an hotel, which became very popular. Colin Dunlop later became chief magistrate of the city and Dunlop Street was named after him. The Buck's Head sign from above the door of the hotel now adorns the roof of the tenement built on the site of the hotel.

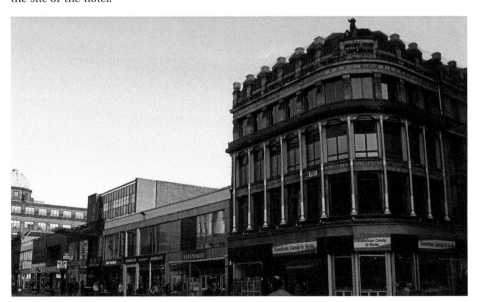

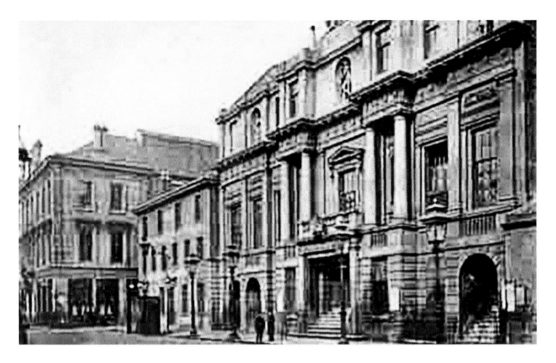

The Theatre Royal: Dunlop Street and Queen Street

Opened in 1782 in Dunlop Street, the Theatre Royal was a big success. A new theatre, also called the Theatre Royal, was built in Queen Street in 1805, next to Andrew Cunninghame's mansion house on the north-west side of the street near George Square. The Dunlop Street audience fell away and the theatre was sold in 1807 to a merchant, who used it for warehouse space. In 1822, it was sold again and became the Caledonian Theatre. The basement was leased to the Theatre of Fancy. In 1863, fire gutted the building, and despite the fact that the theatre had just been rebuilt, it had to be demolished in 1869 to make way for St Enoch's station.

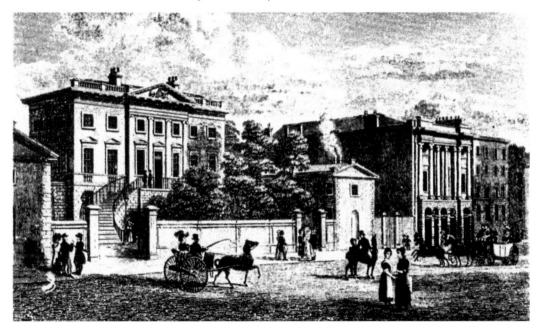

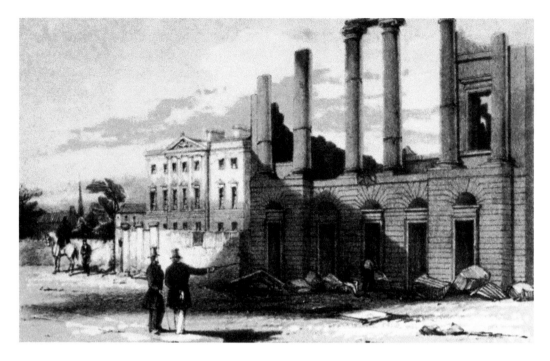

The Theatre Royal: Hope Street

When the Queen Street theatre was destroyed by fire, a new theatre was opened in 1867 at the top of Hope Street by James Bayliss. It was initially called The Royal Colosseum and Opera House, but when Bayliss leased the theatre to Glover and Francis in 1869, Glover brought with him the name 'Theatre Royal' and all its artistes, orchestra and stage crew. This theatre was destroyed by fire in 1879 and rebuilt to a design by renowned theatre architect Charles J. Phipps. It is now the largest surviving example of Phipps' architecture in Britain and is currently having a multi-million-pound extension added.

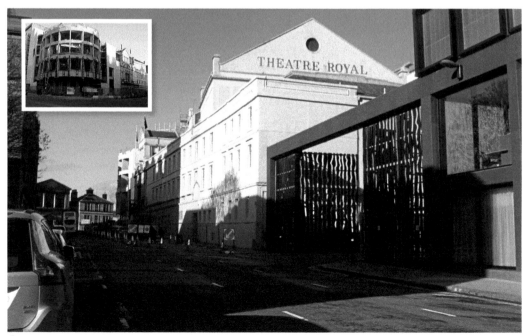

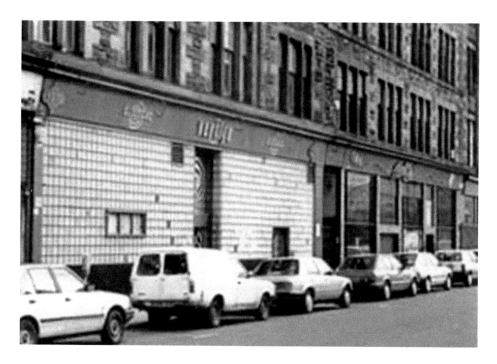

Vertigo: Dunlop Street, 1991

An unusual feature of this nightclub was the elevating dancefloor. Inebriated punters would get up to dance, then be completely lost and unable to find their friends when they came off the floor, because they would have got on at the first level and come off at the second level. A block of luxury flats now occupies this site and recently murals have been painted on the ground-floor walls.

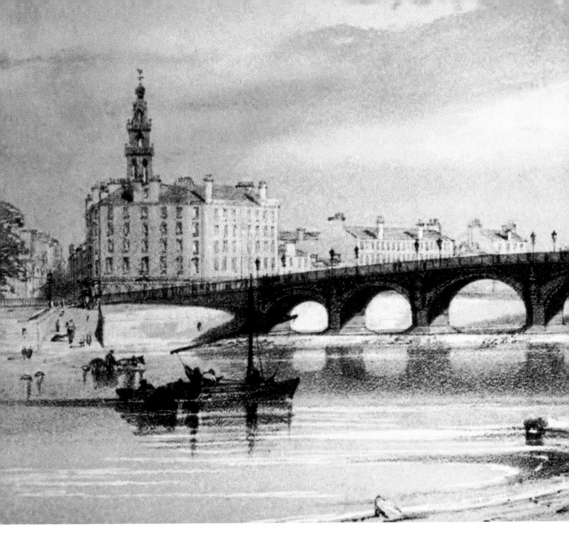

The Old Bridge, 1846
The four-storey building to the left of the bridge is the tenement that sits at the south-east corner of Stockwell Street, with the Popinjay bar on the ground floor. The Briggait Steeple can be seen behind it in this old engraving.

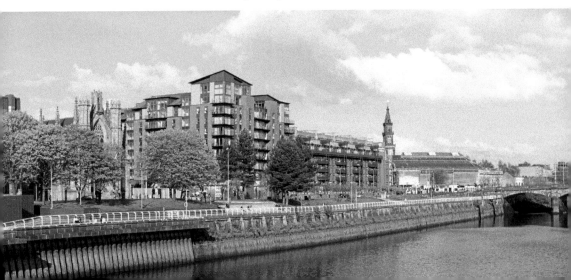

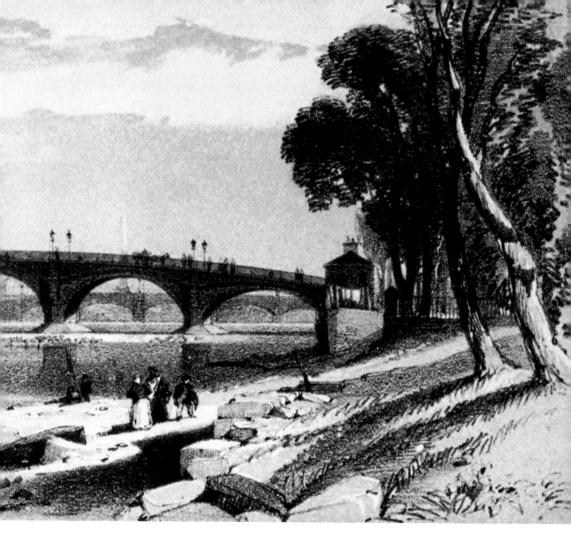

In the new picture below, the four-storey tenement has gone and the roof of the old fish market, the Briggait, can be seen behind the single storey of the Clutha – the scene of the tragic helicopter crash last year. To the left of the Briggait are the flats built on the site where Bob Dragon's house once stood.

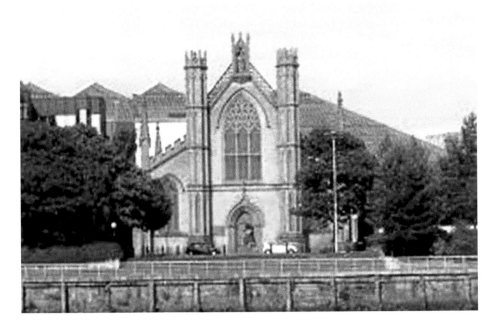

St Andrew's Cathedral

Designed by James Gillespie Graham in the Neo-Gothic style in 1814, St Andre's Cathedral was built in 1916. It is the seat of the Archbishop of Glasgow, the Most Revd Philip Tartaglia, and the mother church of the Roman Catholic Archdiocese of Glasgow. It is dedicated to the patron saint of Scotland, St Andrew. It has recently been renovated and is now much lighter and brighter. The cloister garden is a little haven to sit, in quiet contemplation.

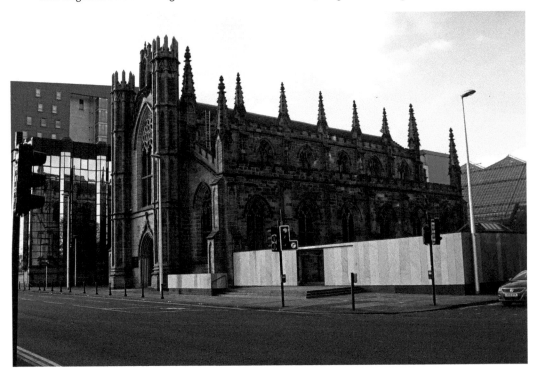

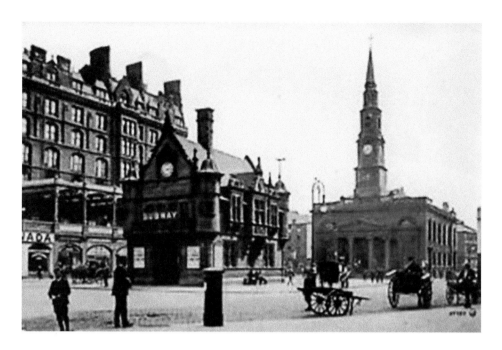

St Enoch Square

This square is named after St Mungo's mother, St Thenew, also known as St Enoch, who was buried here. This view, facing south east, shows St Enoch Hotel and station on the left, the subway station (*middle*) and the St Enoch church on the right. The photograph below shows the new shopping mall on the left, replacing the hotel and station, and the old subway entrance is now a coffee shop. The building bottom left is the new subway entrance.

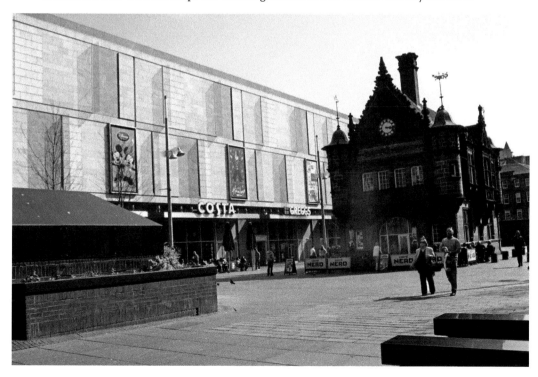

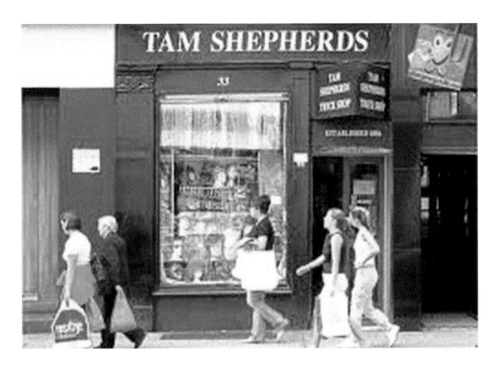

Tam Shepherd's Trick Shop

Established in 1886 and still at the same address (No. 33 Queen Street), this shop is an institution in Glasgow. When the original Tam Shepherd died, the shop was bought by Lewis Davenport in the 1930s, and it remains in the Davenport family to this day. The shop is now managed by Roy Walton, an internationally renowned magician, assisted by his wife Jean (née Davenport) and their two daughters, Julia and Sarah. 'You don't stop playing because you grow old – you grow old because you stop playing!' – that's what it says on their website. Why not pop in and say 'hello – Etta sent me'? Roy might even show you a trick or two.

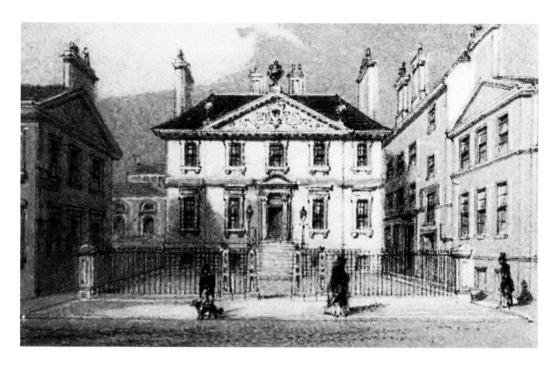

Town Residence of the Late Kirkman Finlay

This house was located about halfway down Queen Street, near the Cunninghame mansion. Kirkman Finlay was a very successful textile merchant. He owned the largest textile company in Scotland and he was the first British merchant to trade directly with India. A very public-spirited man, he was Lord Provost of Glasgow in 1812 and a member of Parliament from 1812 to 1820. A marble statue of him by John Gibson sits in the vestibule of the Merchant's House in George Square. He built Castle Toward on the Cowal penisula as his country home.

Gallery of Modern Art
Situated at the corner of Queen Street and Ingram Street, the Gallery of Modern Art has several floors of artworks, a library and tearoom in the basement, and a shop on the ground floor. It is built around the mansion of Tobacco Lord Cunninghame of Lainshaw. The original double steps leading to the front door were removed and the pillared portico added. The main foyer is part of the original mansion.

The Red Square: George Square, Looking West

This is a view of the square before it was recently dug up to get rid of the red blaise. The post office building can be seen on the left (now luxury flats), and Queen Street station is on the north-west corner. The light-coloured building on the right is the Millennium Hotel. Below, the square is seen looking north-west.

Buchanan Street, Looking South

These photographs show a view of Buchanan Street, taken from the steps in front of the Buchanan Galleries all the way down to St Enoch Square. Note the block of buildings to the right in front of the van, which have now been demolished. The bottom photograph shows a closer view of the new buildings.

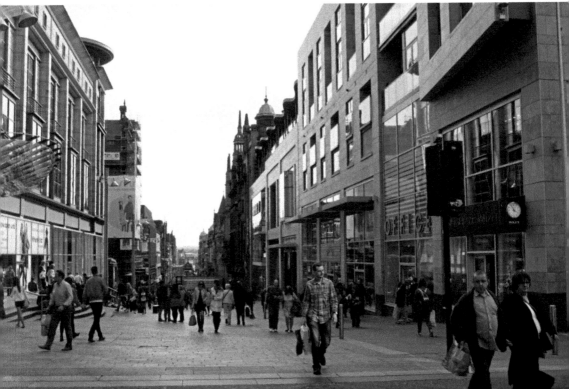

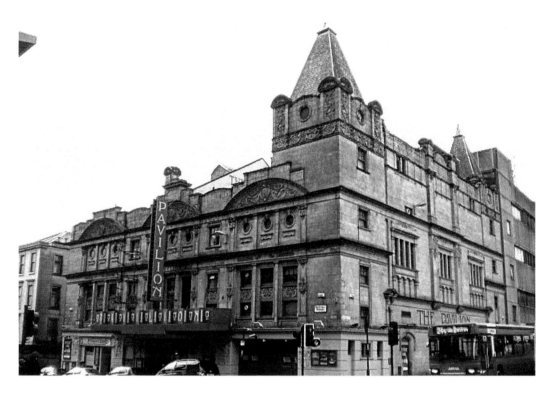

The Pavilion Theatre

Situated on the corner of Renfield Street and Renfrew Street, the Pavilion Theatre, the only privately run theatre in Scotland, reinvented itself in 2007 as the Scottish National Theatre of Variety. The theatre was designed by Bertie Crewe to be the Glasgow Venue for Thomas Barrasford's chain of British music halls. It was regarded as luxurious when it was opened on 29 February 1904. One interesting feature is the system of ventilation – an electrically operated sliding roof panel.

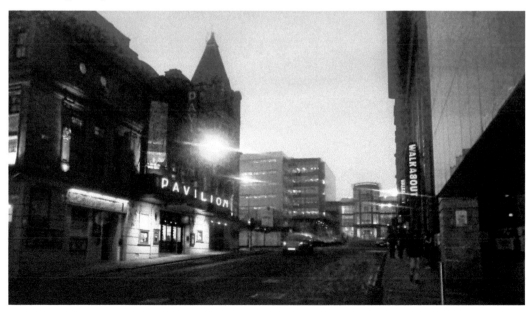

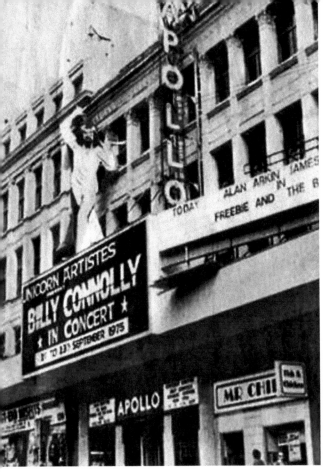

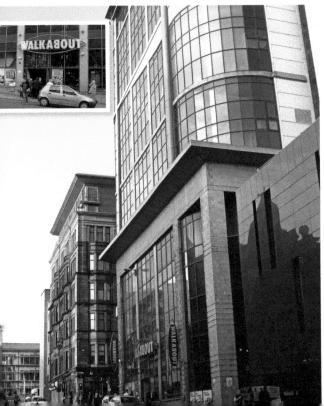

The Apollo

Initially called Green's Playhouse Cinema, then a music and comedy venue at the east corner of Renfrew Street opposite the Pavilion Theatre, the Apollo was a highly respected and sometimes feared venue for live acts, especially for comedians. 'If a Glasgow audience doesn't boo you off, you're made', was the rumour in the entertainment world. Billy Connolly performed to a full Apollo theatre audience for thirteen nights in a row in September 1975, such was his popularity. The bands loved the atmosphere, as the place would be literally jumping. Quite often, to their consternation, they could see the circle moving up and down as the audience went crazy. 'For sheer atmosphere we had to do the Apollo. The place was packed, the sound was great and the audience were ... just something else. You rarely get a gig where everything is just right and all in harmony. It was one of those sublime magical moments, when through some weird sort of alchemy, everyone – the band, the audience, the music, the building – all became one.' (Dave Parsons, Sham 69.) 'The Apollo was the best venue anywhere in the world.' (Francis Rossi, Status Quo.) In 1987, the Apollo was demolished and Cineworld, the tallest cinema in the world, was built on the site.

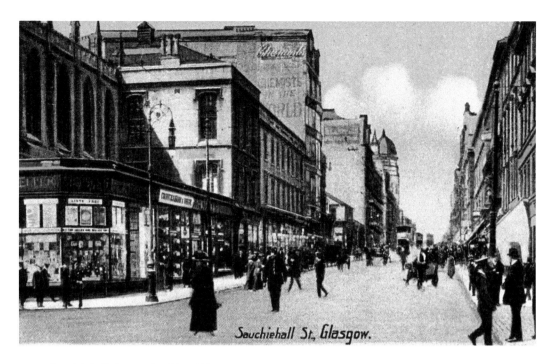

Sauchiehall St, Glasgow.

Sauchiehall Street, Looking West

On the left of this postcard we can just see the north elevation of the Renfield Street United Free Church, which became in 1929 the Renfield Street church of Scotland until it was closed in 1964 (and subsequently demolished) and the congregation merged with Renfield St Stephens church in Bath Street. The whole of that block is now occupied by British Home Stores.

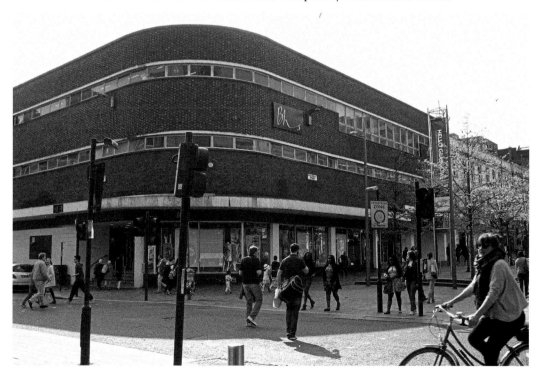

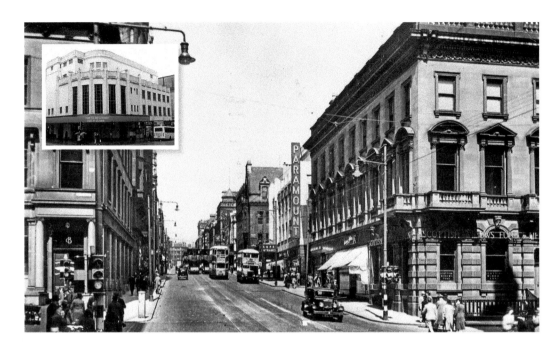

The Odeon, Formerly Paramount Cinema

Opened 31 December 1934 and closed 7 January 2006, this Art Deco cinema was the only one of the 'super cinemas' designed by London architects Frank Verity and Samuel Beverley to be built in Scotland for the American company, Paramount. In 1939, all of the UK Paramount cinemas were sold to the Odeon Group. The Glasgow Odeon continued as a cinema and theatre, interspersing films with live shows of bands such as the Beatles and the Rolling Stones, until 1970, when it was closed for refurbishment. A year later, the massive auditorium, seating around 2,800, had been divided into three smaller screens. Further sub-divisions in 1988 and 1999 increased the number of screens to nine. The building has now been demolished and a new building is being erected behind the original façade.

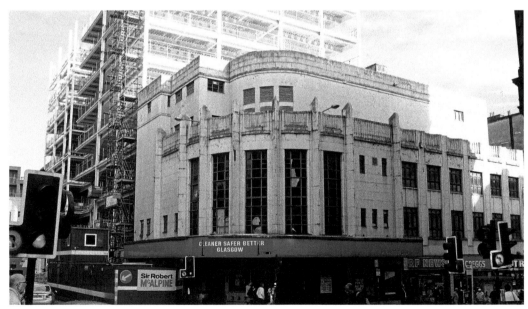

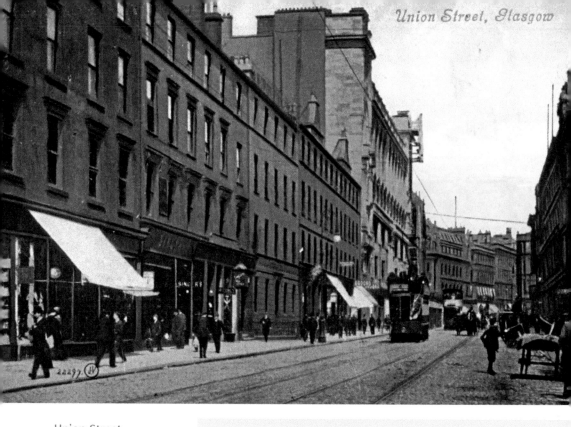

Union Street, Looking North

Here we can see Duncan's Hotel, to the left of the open-topped tram and butting on to the taller building, which is Central station. Duncan's Hotel is one of only two buildings left that used to be in Grahamston. In the new picture (*right*), the name of the hotel has been changed to the Rennie Mackintosh Station Hotel and it is now light in colour.

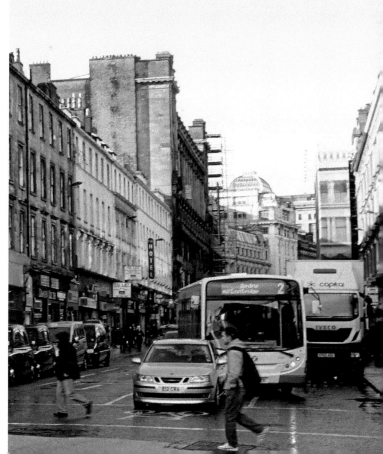

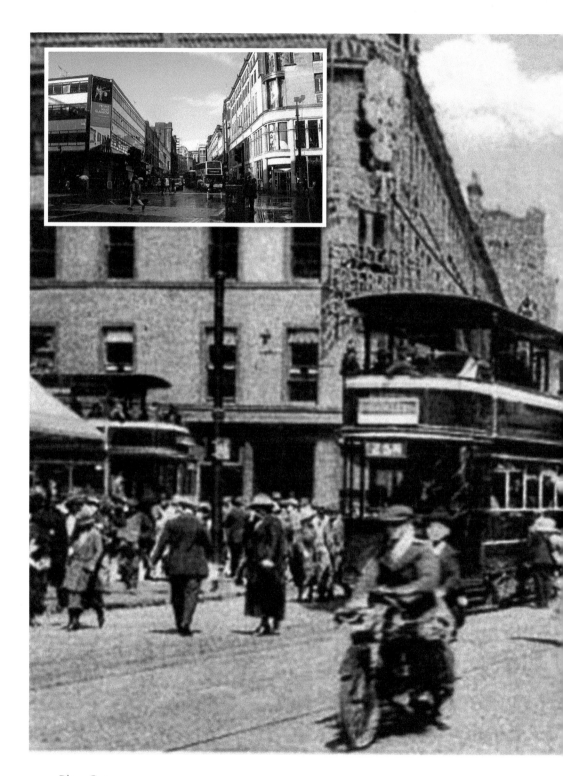

Dissy Corner

The corner of Union Street and Argyle Street is known as 'Dissy Corner' because it was common for young men to arrange to meet their 'dates' under the clock. If the 'date' didn't

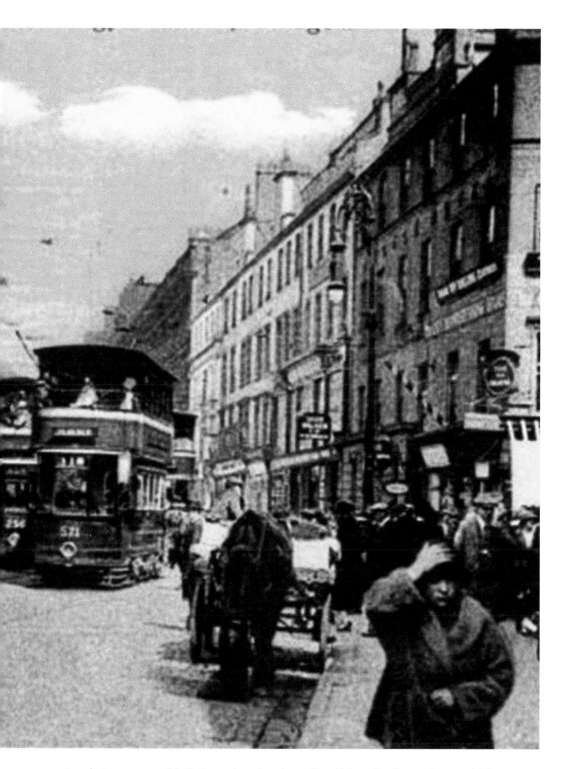

arrive, their mates would rib them about 'getting a dissy' (short for disappointment). There were no mobile phones in those days to check instantly what was happening with the other person. For a long time, Boots occupied this entire corner (*inset*) but now it is a KFC.

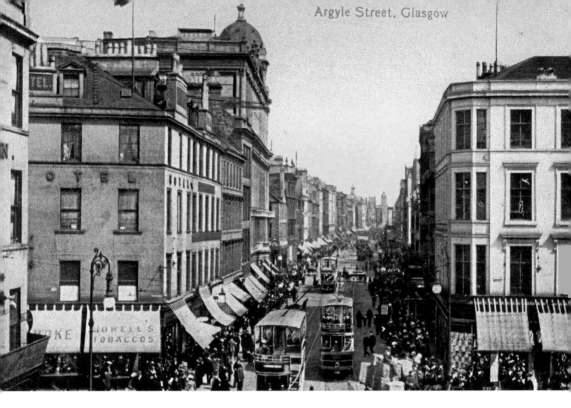

Argyle Street, Glasgow

Looking East Along Argyle Street

Going by the number of sunshades out, I would guess that it was quite a hot sunny day when the top photograph was taken. Below, a large graphic of Col. Sanders occupies the space where the clock used to sit.

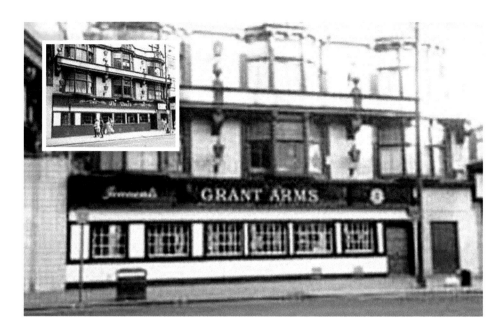

The Grant Arms

Previously called 'Gamps' and 'Da Vinci's', the Grant Arms is the only other building to survive the demolition of Grahamston required for the construction of the Central station (the first being Duncan's Hotel). Here we see the railway bridge spanning Argyle Street, nicknamed the Hielanman's umbrella because the Highlanders who came to work in Glasgow would arrange to meet under the bridge, knowing that they wouldn't get wet.

James Watt's House

This house would have been in quite an idyllic, rural situation when James Watt lived here, and just a few steps away from the River Clyde at the Broomielaw. It was on a lane (Delftfield Lane) running north from the Clyde. Watt became a shareholder in Delftfield Pottery, which was also on Delftfield Lane. It is easy to imagine him wandering eastwards along the side of the Clyde, turning over ideas in his mind. In partnership with John Craig, he set up a workshop in the Saltmarket, then in the Trongate. Delftfield Lane was later named James Watt Street in honour of Watt's achievements. How different this street must have been in the days of the Tobacco Lords. These huge warehouses being filled with tobacco, sugar and cotton imports – it must have been a bustling, noisy, smelly place. Now it's deserted and just by being there you get the feeling that you're disturbing ghosts of times past.

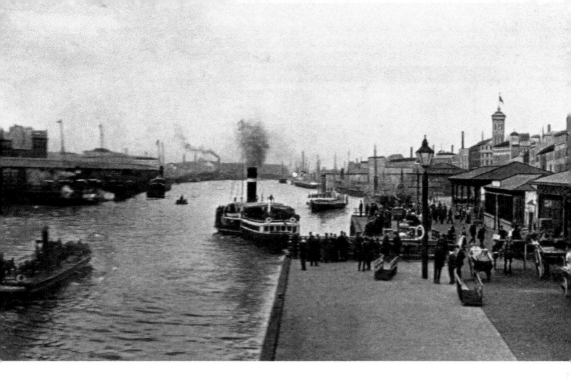

The Broomielaw

Originally called Broomy-law-knol, because of the amount of broom in a field around what is now Oswald Street, the Broomielaw would dry out at low tide, until dredging took place in the mid-nineteenth century. This caused great inconvenience to the Glasgow merchants who would have to transfer their goods from their big transatlantic ships docked at Port Glasgow and Greenock into smaller boats known as gabbarts (small one-masted vessels with a square sail) in order to transport them into the heart of Glasgow at Broomielaw Quay. Sometimes these boats would be towed between Renfrew and Glasgow by horse power.

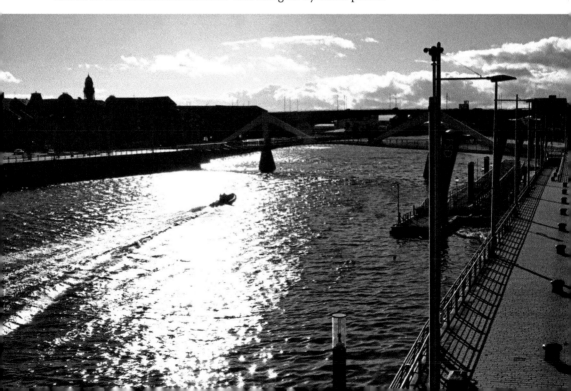

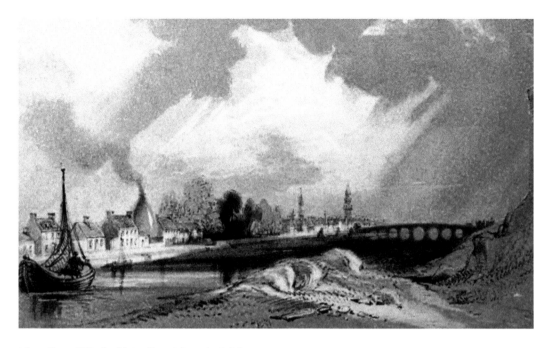

View from Windmill Croft to Victoria Bridge

There are now five bridges between this artist's viewpoint and Victoria Bridge, the oldest bridge in Glasgow. Designed by James Walker and opened in 1854, the 50-foot-wide Victoria Bridge (named after Queen Victoria and replacing the wooden Bishop's Bridge, *c.* 1285) was the second widest bridge in Britain, London having the widest at 54 feet. The Bishop's Bridge was mentioned by Blind Harry (*c.* 1440–92) in his epic poem about Sir William Wallace. The new photograph has been taken from between the first and second of the five bridges, and shows a view looking east towards the George V Bridge.

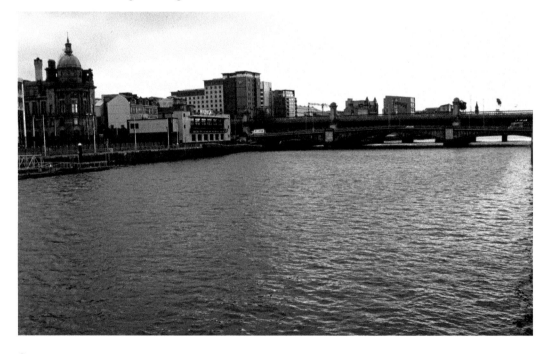

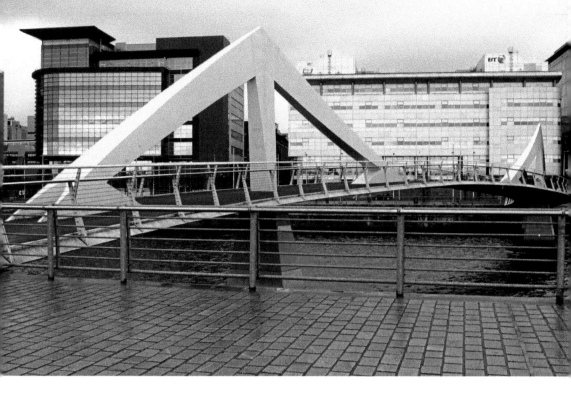

The Squiggly Bridge

The first bridge in this stretch of water is also the newest in Glasgow, the Tradeston Bridge, known locally as the Squiggly Bridge. This £7 million pedestrian bridge, opened on 14 May 2009, links Tradeston with the commercial centre of Glasgow on the north side of the river.

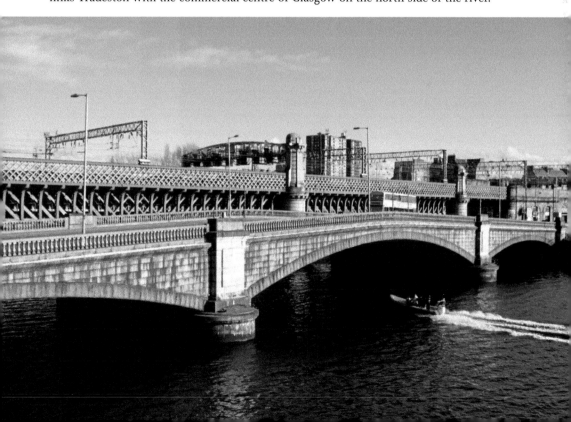

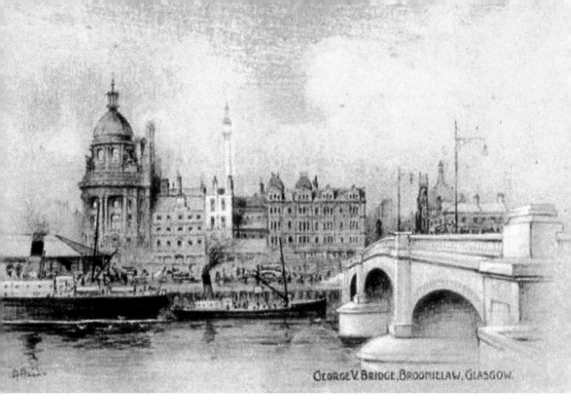

GEORGE V BRIDGE, BROOMIELAW, GLASGOW.

George V Bridge, Broomielaw

This bridge, designed by Thomas Somers, a city engineer, was opened in 1928. It was originally commissioned in 1914, but was delayed due to the First World War. It links the Tradeston area to Oswald Street. This view, looking from south to north shows the red sandstone Clyde Port Authority building, with its domed roof, on the north bank of the Clyde. In the photograph below, the Riverboat Casino can be seen to the left of the bridge. The Caledonian Railway Bridge (built 1899–1905), seen to the right, spans the Clyde between the George V Bridge and the Jamaica Bridge.

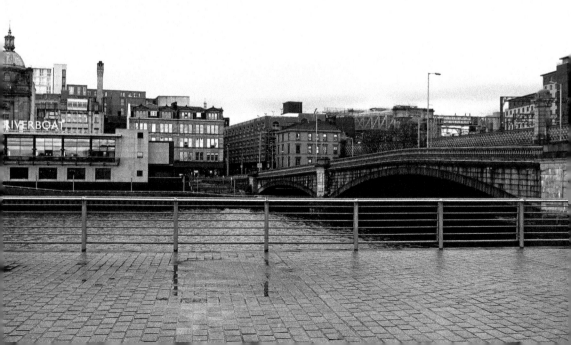

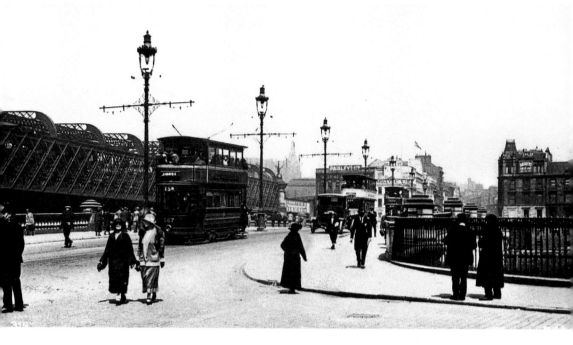

Jamaica Bridge, Looking North

In the top picture, the first Caledonian Railway Bridge, built in 1878, is seen to the left. In 1966/67, the tracks and girders were removed, leaving only the original piers that can be seen today between the second Caledonian Railway Bridge and Jamaica Bridge. When both railway bridges were in operation, they formed the widest railway-over-river bridge in the country, spanning up to 194 feet. In the new photograph, a Jury's Inn can be seen on the north side of the river, replacing the old Paisley's Department store. The old-style lamp posts have been replaced with a modern design, the road is now one way heading south and there is no traffic access to Carlton Place on the right.

South Portland Street Suspension Bridge

The last bridge in the stretch of the Clyde between the Squiggly Bridge and the Victoria Bridge. This pedestrian bridge, designed by engineer George Martin, was opened in 1853 after suffering a major setback. The south tower split from top to bottom when the main suspension chains were added. The towers had to be rebuilt and despite the fact that all other parts of the bridge have been replaced, those same towers still stand today, making them the oldest surviving bridge parts in Glasgow.

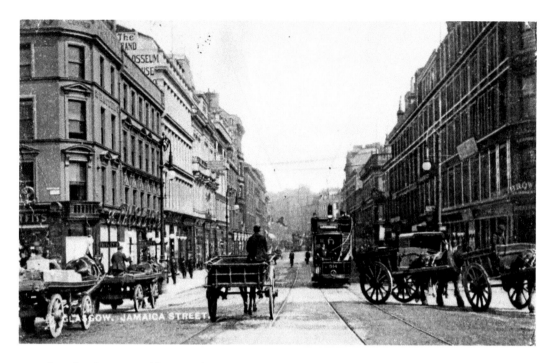

Jamaica Street, Looking North

This old postcard, posted 21 December 1905, shows the transport of the day, horses and carts and an open-topped tram. Paisley's department store, a clothing retailer, seen on the left (now a Jury's Inn) was famous for stocking school uniforms. The next building to the north on the west side of the street is the Grand Coliseum Warehouse, founded in 1873 by Walter Wilson and taken over by Dallas's in 1936. There is now a Euro Hostel on the south-east corner of Jamaica Street providing cheap accommodation.

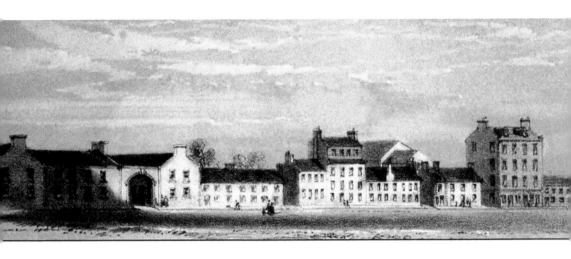

Grahamston: A Village Vanished

Once a thriving community, important to Glasgow, Grahamston is now buried beneath the Central station. Platforms 3 and 4 run over the main thoroughfare, Alston Street, on which stood Glasgow's first permanent theatre. It's rumoured that, given access, you could still walk along that street. John Logie Baird made history in 1926 when he sent television images long distance (from London to Glasgow) through a telephone wire to his assistant Ben Clapp in the Central Hotel.

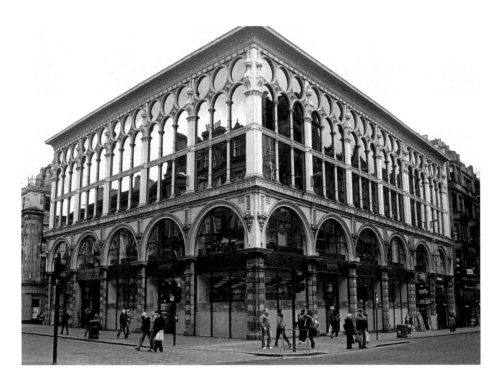

The Ca' d'Oro Building

Sited at the south-east corner of Union Street and Gordon Street, the Ca' d'Oro building, designed by the architect John Honeyman, opened as a furniture warehouse in 1872. It became known as the Ca' d'Oro building when a restaurant of that name opened in the mansard roof, designed by J. Gaff Gillespie and completed by Jack Coia in 1927. In 1987, a fire gutted the building, leaving only the cast-iron frame. When it reopened in 1990, Waterstones bookshop occupied the ground floor. A number of different retailers now occupy the ground floor with offices above.

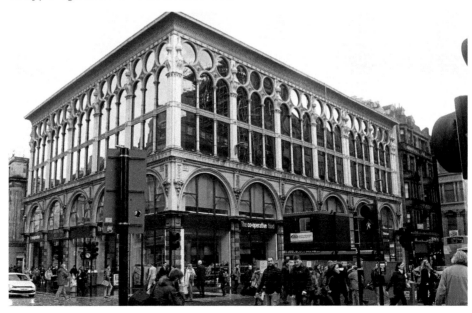

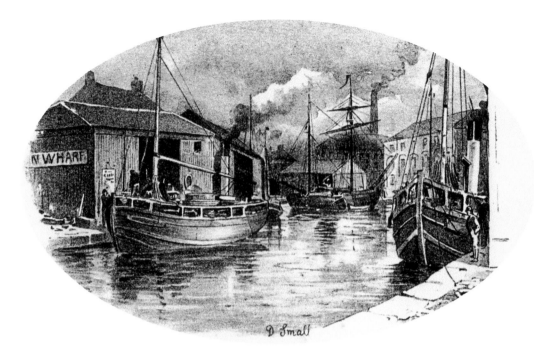

D. Small

Speir's Wharf

In 1904, Walter McDonald Bergius, aged twenty-three, founded his own company designing and manufacturing cars. Two years later, his brother suggested putting the engine that Walter had invented into a Rowing Gig. They called the boat KELVIN. It won every race it was entered for on the Clyde estuary. Bergius went on to develop the engines to run on paraffin as well as petrol. These engines were highly successful and were used widely by fishing smacks, which would come up the Forth & Clyde Canal and into the Bergius boatyard at Cowcaddens to have the new engines fitted. In 1921/22, Bergius designed the single-sleeve valve models, which were extremely silent and were used during the Second World War in the Commando raid on the Lofoten Islands in northern Norway.

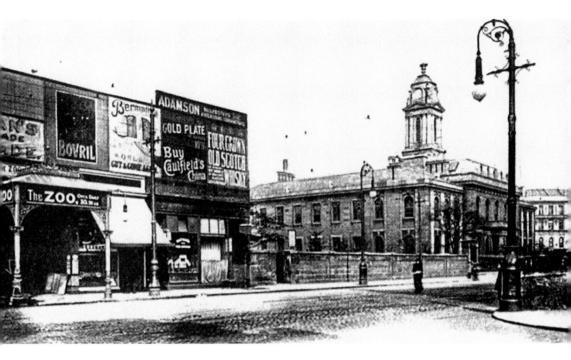

Bostock's Zoo and Normal School

Seen above around 1898, Bostock's Zoo in New City Road was the first permanent zoo in Scotland. E. H. Bostock settled in what was a very large but run-down building in 1897. His circus shows were spectacular but he also introduced film to the venue, having brought a colour film of Cinderella from Paris. The Normal School, Glasgow's first teacher training college, can be seen to the right. The buildings once occupied by the zoo now form Chinatown, including a very nice Chinese restaurant. Above the restaurant is a snooker hall.

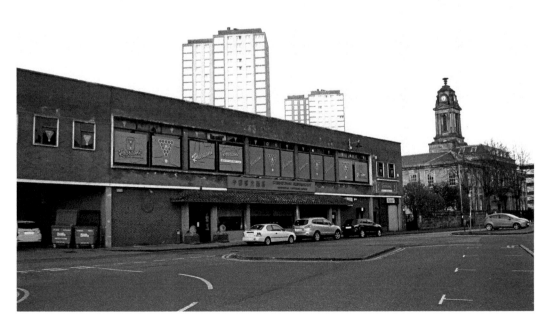

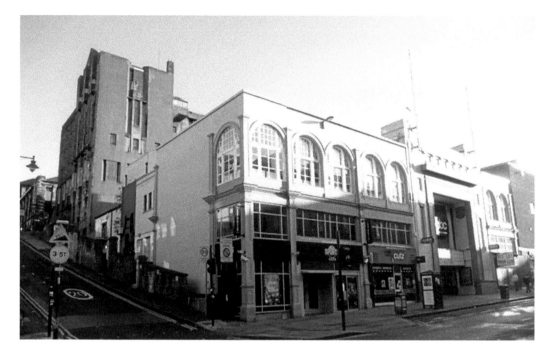

O2 ABC

Built in 1875 as a diorama, this building was converted in 1878 to a panorama, then in 1885 it became Hubner's ice skating palace. In 1888, the building was one of the first in Glasgow to have electricity installed, which led to the venue being used for Glasgow's first public showing of a movie. It was then converted into a Hippodrome, which hosted Hengler's Circus and between circus shows it was used as a cinema. In 1929, it was transformed into a dancehall, the Waldorf Palais, with a car park on the ground floor and the main dance hall on the first floor. Later it was converted back to a cinema, the Royal Cinema, then divided into smaller screens. Eventually it was closed in 1999 and reopened in 2005 as a nightclub and music venue.

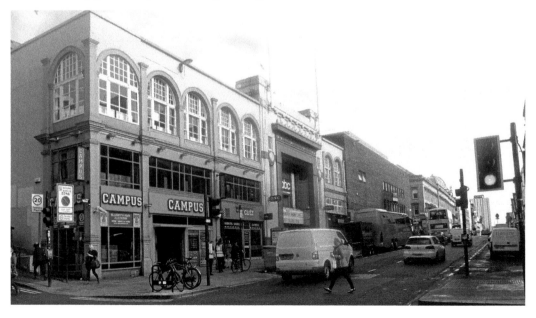

The Willow Tearooms

Kate Cranston, daughter of a tea merchant, was a strong advocate of the Temperance Movement. She gave Charles Rennie Mackintosh total responsibility for the design of the Sauchiehall Street tea rooms. For the previous tea rooms, he either had the murals or the furniture to design – but not both. His wife Margaret Macdonald had a lot of influence in this design. The tea rooms at No, 217 Sauchiehall Street opened for business in October 1903. The rooms were themed – dark for the men's smoking and billiard rooms and light for the ladies tea rooms. Now Hendersons the jewellers is on the ground floor, selling a wide range of Rennie Mackintosh-style jewellery.

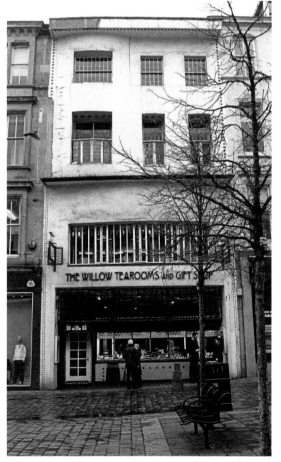

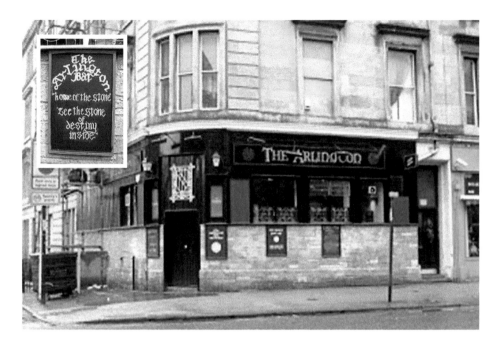

The Stone of Destiny at the Arlington Bar

Straight in front of you as you step into the Arlington Bar, you'll see a niche with coloured bulbs highlighting a huge stone. The landlord claims that it is the real Stone of Destiny and that the one handed back by the group of students (regulars of the pub) who stole it from Westminster Abbey was, in fact, a copy. Ian Hamilton, ringleader and ardent Scottish Nationalist, was caught after police discovered that an abnormally high amount of books about Westminster Abbey had been borrowed from his local library. 'When I lifted the stone in Westminster Abbey, I felt Scotland's soul was in my hands,' he said. 'This was an ancient wrong that had to be righted, I was just the person who did it.' This heist took place on Christmas Day 1950. In 2008, a film was made about it directed by David Lean. Ian Hamilton is now Ian Hamilton QC. Don't believe it? Go to the Arlington and talk to Paddy. Tell him Etta sent you.

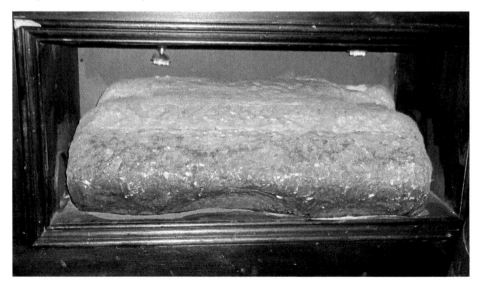

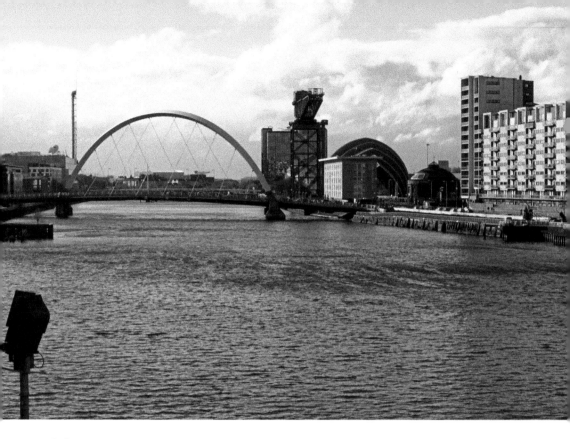

Clyde Arc

Acknowledgements

I wish to express my grateful thanks for the help given to me by the following people and institutions: Peter Duffie, my partner, without whose help patience and support this book would not have been possible; David Shanks, my friend, for sharing his innate, astounding knowledge of Glasgow; the staff at Mitchell Library; and Sue Reid Sexton for informing me about Creative Commons.

For granting me permission to use their images: Robert Pool for images from Robert Pool's Glasgow Collection (www.flickr.com/photos/robertpool); Graeme Smith, for images previously used in his books *The Theatre Royal: Entertaining a Nation* and *Alhambra Glasgow* (www.glasgowtheatreroyal.co.uk); John Gorevan for images from his books *Glasgow Pubs and Publicans* and *Up and Doon the Gallowgate* (www.oldglasgowpubs.co.uk); Judith Bowers for images from the Britannia Panopticon Music Hall; *The Story of the Britannia Music Hall* by Judith Bowers; Martin Kielty, Scott McArthur and Andy Muir for images from their book *Apollo Memories* (www.glasgowapollo.co.uk); the University of Glasgow for an image from the Glasgow Special Collections; the National Library of Scotland for an image from their collection; and David Nugent and Chris Downer from Creative Commons.